by **JULIA ROTHMAN**, **JENNY VOLVOVSKI**, and **MATT LAMOTHE**

foreword by **DAVE EGGERS**

SITE BOOK

CHRONICLE BOOKS
SAN FRANCISCO

THIS BOOK IS A GAME, AND IT GOES LIKE THIS:

The first player draws a picture (*a scientist gets shocked by a live wire*), then passes it on to the next person, who continues the story with a drawing (*an incomplete time machine*). With each pass, the story continues (*Abraham Lincoln riding a triceratops*).

The one rule is that each player is only allowed to see the preceding page. When the last page is complete, the entire series is revealed, and all players see how their pictures fit into the story.

This game is a modified version of Exquisite Corpse, which was invented by the Surrealists in the early 1920s. The original game takes place on a single sheet of paper. On the top third, the first player draws a head, folds it over leaving only the neckline, and gives it to the second player, who then draws the midsection. The third player creates the legs and feet. When the paper is unfolded, all three players are able to see the character they have created.

We — Julia, Matt, and Jenny — the authors of this book, met a decade ago at the Rhode Island School of Design (RISD). During art history lectures we invented more complex versions of the game. For two hours every Tuesday and Thursday in a darkened auditorium, we filled notebooks and napkins with visual narratives. It's quite likely that the three of us failed to become experts in the history of Han Dynasty pottery because we were passing notes instead of taking notes. After graduating from RISD we continued to collaborate by starting a design company. As ALSO Design, we create Web sites and print work for small, independent companies as well as for individual artists and makers.

In addition to the work we do for our clients, we also like to work on our own personal, self-driven projects. One of these is Julia's book blog, Book-By-Its-Cover.com. Each day she posts a short review of a new art book and often features artists' personal sketchbooks and interviews. As we collected content for the blog, we were delighted to find how many of our favorite artists were willing to share and discuss their work with us. These successful small collaborations led us to believe we could organize a larger project, and we came up with the idea of repurposing the Exquisite Corpse game for the book blog. The more we thought about it, the more we agreed that a printed format would suit the project better.

It took a good deal of modification to transform the Exquisite Corpse game into a book. We decided to have one hundred participants, each of whom would be responsible for a stand-alone page in an ongoing narrative. Each artist had two weeks to complete their artwork, and for the sake of time, we divided them into groups of ten, with each group in charge of a different chapter. With all sections working simultaneously, it took a little over five months to create all the artwork.

INTRODUCT

The first artist in each chapter was given a phrase, for example: "In the clouds…" or "In the mountains… " or "In the snow…" We chose a variety of locations that were open-ended enough for each artist to interpret, but also served as a way to tie the whole book together. We also wanted to ensure that a visual connection would exist between the pages, in the same way that Exquisite Corpse players left a part of their drawing visible for the next participant. For *The Exquisite Book*, each artist was instructed to work a horizon line into the piece, to be continued by the next artist.

The artists interpreted the rules very differently. Some looked at the page before theirs and continued the story in a narrative way, like the next frame of a comic strip. Others treated their piece as an extension of the page before it, as if it were one long visual panorama. Some artists were less literal, picking up on the colors, shapes, patterns, or overall "feel" of the piece. The personalities of the artists really emerged with these decisions. With each new submission, we excitedly rushed to add it to the existing chain to see what kind of connection was made.

For example, a seamless connection was created between Mike Bertino's and David Heatley's paintings. Mike's page shows many characters corralled within a fence, some of them cropped on the right side of the page. David completed every character that was cut off by the edge, making the two pages appear as one continuous drawing. Mike's and David's styles aren't very similar in their other work, but here David blended the pages so well that it's difficult to believe they were made by two different artists.

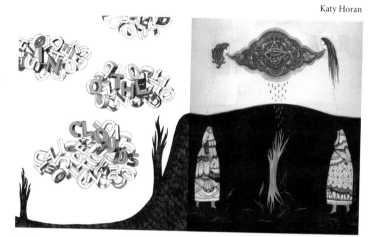

Katy Horan

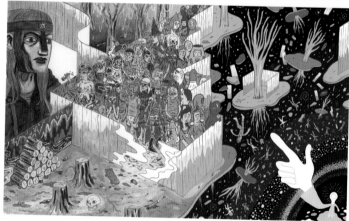

Mike Bertino, David Heatley

Mimicking the composition of the previous page turned out to be a popular approach to the project. The shape of the volcano in Ryan Jacob Smith's page is repeated on AJ Purdy's, but is interpreted as curtains surrounded by an angelic design. Betsy Walton's wolf is flipped horizontally and wears a sweater in Liz Zanis's page. The human and penguin characters in Nick Dewar's image appear in Leif Parsons', except the clothing is swapped. In a similarly playful vein, Calef Brown transforms Pascal Blanchet's lady walking a choking dog into a dog walking a human skull.

Most surprising to us were the connections that spontaneously occurred between nonsequential pages. Imagery reappeared throughout certain chapters. Pirate ship imagery is carried from Eunice Moyle's page to Laura Ljungkvist's but then disappears in Claudia Pearson's. You can imagine our surprise when Julia Pott's page included a pirate boat again. In Henrik Drescher's piece, a red beam comes out of a woman's head; two pages later, Kate Bingaman-Burt uses a beam of a similar shape and color radiating from a 99¢ symbol. Melinda Beck uses bright multicolored polka dots on her character's clothing. The next artist, Juliette Borda, makes no reference to the patterning, but the artist *after* her, Mike Perry, integrates bright polka dots into his design!

We thought it was funny when Aaron Meshon decided Tom Neely's dogs needed to "cool down." He took the growling black dogs and stuck them in a Japanese bathhouse. Unfortunately, their spa retreat was only temporary. Jordan Crane placed them into gigantic flames a page later.

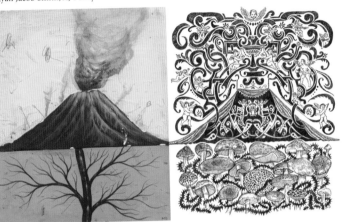

Ryan Jacob Smith, AJ Purdy

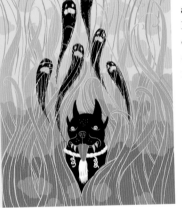

Tom Neely, Aaron Meshon, Jordan Crane

The horizon lines were also interpreted in a variety of ways. They became mountains, water, rooftops, and rainbows as well as hat brims, beards, telephone wires, animal tails, and a contour of a woman's face. Kate Bingaman-Burt made hers out of word bubbles and Joe Hart had his explode in the middle of the

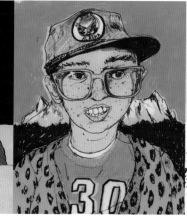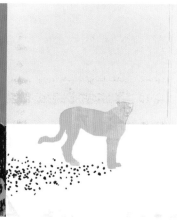

Matt Leines, Ward Zwart, The Heads of State

page. While all the groups' horizon lines twisted and turned, one group's stayed completely straight. Once Matt Leines set the tone for the "In the Snow" chapter with his straight horizontal line, almost everyone in the group followed suit.

Some artists included very subtle connections between the pages — ones you might miss the first time around. Jen Corace, for example, scattered the papers that Simon Peplow's character was reading throughout the pond. Irina Troitskaya repeated the framework of Isaac Tobin's billboards in her treetops. Joel Trussell was very thorough in transferring over elements from Mikel Casal's image. All of the character's clothing is strewn about the room—the umbrella is off to the side, the diamond shapes are repeated on the floor, and the bird is seen through the open window.

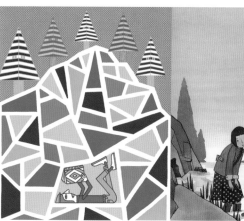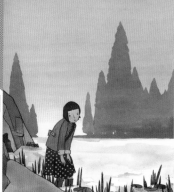

Simon Peplow, Jen Corace

As artists sent in their finished pieces, we were excited to discover the subtle (and not so subtle) connections between the pages. It was equally satisfying to see a narrative fully continued as to find connections the artist may not have intended. The variety of interpretations, along with the imagination and skill of the artists, makes this book engaging, surprising, and unique. We are truly grateful that so many artists from all around the world were excited to participate and create such incredible works of art. We hope you find it as exquisite to read as we found it to make.

THERE IS NO MORE SIMPLE WAY TO DEMONSTRATE THE STRANGENESS OF HUMANKIND THAN THE EXQUISITE CORPSE.

Foreword by DAVE EGGERS

But there is something affirming and connecting about this form. Though together we make a rowdy and meandering — even dissonant — narrative, we've made this rowdy and meandering and dissonant narrative together, and that provides some comfort.

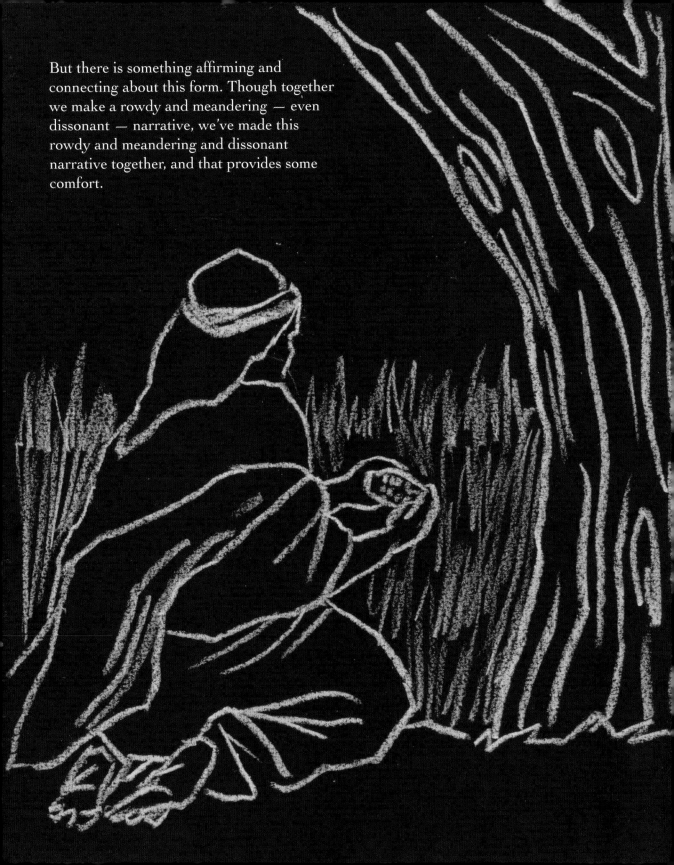

20 QUESTIONS

1. **What do you enjoy about the Exquisite Corpse game?**

MATT LEINES: Obviously, the fun of the exquisite corpse is the mystery of what the drawing will look like when all parts are finished. The parts I enjoy best, however, are the chances taken while drawing your part. For instance, you could do your drawing based on the assumption of what you think the person before you might have done, only to discover that they assumed that you would be basing yours on that assumption and instead they went a completely different direction. Or the opposite scenario. It's a great exercise in trust and telepathy.

2. **If you could collaborate on an exquisite corpse with any two people, dead or alive, who would they be and why?**

ZACH KANIN: Both of my people would be dead (no offense to those people who are still living, of course), because I've always wanted to ask a dead person whether you need to bring your own linens and towels to heaven, or if they are provided. I can see it going either way. The first dead person I would pick would be Rembrandt. Rembrandt was a great, great artist, and it would be an honor to work with him. He was also notoriously bad at drawing feet. For this reason I would have him do the bottom third of the drawing. Then people might start thinking "What's the big deal about this Rembrandt guy anyways?" and they would pay some more attention to my finely wrought torso work. The second dead person I would pick would be Babe Ruth, to do the head. It is common knowledge that Babe Ruth drew some of the most erotic faces of all time, which is, of course, the area where most exquisite corpses fall down. My runner-up choice would be Audrey Hepburn, who I think has always had a thing for me.

3. **You've curated a series of big group shows as part of your *Panorama* project and shows based on the Exquisite Corpse idea. What interests you about collaborative projects?**

JORDIN ISIP: With our Exquisite Corpse–inspired projects there is, of course, the pleasure of visual non sequiturs and unexpected juxtapositions. For co-curator Rodger Stevens and me, the thrill is also seeing how the artists, coming from many disparate fields, interpret and react individually to the given parameters of our riff on the game. These inspired, innovative, and playful responses, which culminate in a single, continuous work comprised of hundreds of individual pieces installed on a gallery wall, create a grand and unpredictable visual synthesis. Bringing together the participants, all friends and colleagues, was also a reason to reconnect — and make new connections — a form of socializing and interacting creatively when often the life of an artist, especially in this era, is a solitary act. We really just wanted to have an excuse to get together, have fun, and throw a big ol' party.

4. **You often collaborate with other artists when they visit you at your residency, Islands Fold. Can you explain the process of creating a collaborative drawing, sharing the space?**

LUKE RAMSEY: We usually start with a verbal idea before putting it on paper. It can start by one artist setting up the other with a path they think the other will follow. It's fun because you never know if the other artist will follow, or create a different direction. I try to meld my drawings with the other, as opposed to just trying to make my mark. Just doing your own thing with another is losing sight of the rare opportunity.

I think sharing the space isn't a concern, it's knowing when to say the piece is done. Trying to fill every inch of a page can get overworked. That can be fun if it's just messing around, but doesn't always work if you have a vision or narrative to create.

5. **You're one of the artists who started a chain ("In the forest . . ."). Share your thoughts behind your image.**

MELINDA BECK: In high school I read Dante, well, just the first page. Now like Dante I am in the middle of the journey of life and deep in the woods. This image is of the feeling of being in your forties. Not the gritted teeth, anger, and rage of twenty or thirty, but something more insipid and banal, a slow winnowing away at what is you. A place where one's demons take the form of a flock of yellow Post-its.

6. **Joseph Hart's page was so abstract. How did you come up with the idea for your page without much of a narrative?**

LAUREN NASSEF: I felt really lucky to get Joe's page. It is so beautiful and open-ended. I think I spent the whole first week just staring at it. After a while, an image started to emerge and then all I could see were dead grasses and leaves sticking up through snow. The pink shapes looked like flowers but also like blood drops mixing with melting ice. I decided to draw a scene that explained why the snow would be splattered with blood, while at the same time mimicking Joe's color and compositional choices.

I ended up with a story about a pack of snow leopards that snuck onto a farm on the edge of a small town. They surrounded a bull and forced it back up into the woods where they lived. Just after they killed it, they were interrupted by the sound of the farmer calling and searching for his lost bull.

7. **In your image, the horizon from Nigel Peake's piece becomes the chin and neck for the face in your piece. Did you imagine Nigel's shapes taking on this form right away, or did it evolve slowly in developing your own composition?**

DEANNE CHEUK: The part of Nigel's illustration that I used as my girl's chin really stood out to me immediately as having the possibility of a chin shape; I just went with it. I didn't want to think about other possibilities after I first thought of that as there just wasn't enough time—I would have loved to have played around with other possibilities endlessly if I could have!

8. **Your page seems like a departure in style from much of your other work. How much of this was a reaction to Marcus Oakley's page?**

CAITLIN KEEGAN: I was thinking less about the style and more about what the bird man would do next. Mostly I tried to get inside the mind of the bird man. It seemed like he was on a long journey and I thought maybe he wanted to stop and think for a minute. The hat he's wearing signaled to me that he's more of a cigar-smoking type.

On my own I may not have chosen pink and yellow, but I liked the way they looked together in Marcus's painting and thought that using similar colors would help to connect my work to his. I thought the close-up might make for a more cinematic experience, plus it gave me an excuse to draw the feathers in more detail.

9. **Your piece is embroidered, like many of your other works. Can you explain your process start to finish?**

TAKASHI IWASAKI: First I construct a 1½-inch-thick wooden canvas stretcher, and then stretch fabric over it, and staple the fabric tightly and evenly so it will have nice tension to work on, and I'll know exactly where the edges of the work will be in the end. Second, based on a sketch I did on a sheet of paper, I transfer the image onto the fabric. If I'm working on a lighter-toned fabric, I use regular pencil; on a darker-toned fabric, a white pencil. I usually decide which colored thread will be used while I'm stitching, instead of doing it in the sketching phase, because deciding colors is a part of my joy, which I prefer enjoying gradually rather than all at once. When I need to work on or near the edges, I remove part of or the entire fabric from the stretcher and stretch the part to be worked on an embroidery hoop. Maybe I shouldn't be saying this, but the process of stitching is enjoyable yet repetitive and can be mundane once it becomes a habit, so I often ponder over something completely irrelevant to embroidery while I'm stitching. This process actually gives me a lot of time to think about other projects and concerns, so it is a positive by-product of my art-making process. At the end of stitching and enough pondering, I become a philosopher. I re-stretch the parts that I have removed from the stretcher back to the stretcher, and then entitle the work based on the theme with which I was working, and put the title on the back of the work.

10. **At the last minute you decided to revise your piece. What made you rethink your page?**

SIMON PEPLOW: My initial thoughts on receiving Katy Horan's beautiful piece was to tiptoe out of my comfort zone and create something more textured, using solely traditional means, but at the same time retaining my linear/graphic style. I felt a personal pressure to complement Katy's piece, and in doing so, decided to create a painting for the book project, as opposed to my usual method of mark-making, which involves various fine liners, scanning and coloring on my Mac. I'm not a strong painter, and struggled to develop the desired character and color scheme; I was hoping for a coherent composition, one that I was happy to have published. So I came to the conclusion that I needed to rewind and focus on my trusted methods of working, retaining the elements that did work on the painted piece. What you see within this book are the fruits of my revision.

11. **As a book designer, were there any similarities in your approach to this project compared to your design work?**

ISAAC TOBIN: I was actually worried about this project at first because I'm not used to supplying the content for my work; my covers are always direct responses to an author's ideas. But when I saw Kate Bingaman-Burt's page I realized I could react to her imagery the same way I do to a book, even though there wasn't a literal narrative to interpret. It was fun to respond to both her thematic and visual choices.

I also found the process similar to designing book interiors. One of my main considerations when designing an interior is the way each page builds on the previous one (setting up consistent hang lines and drops, establishing a rhythm, etc.). It was interesting to try to achieve some of those same relationships on a single spread without knowing the larger context of the book.

12. **Your dogs went through quite a metamorphosis from your page to Aaron Meshon's to Jordan Crane's. How does it feel to see your characters carried through other pages?**

TOM NEELY: I usually don't collaborate with my art very much, so the whole idea was a new experience for me. I took the rain from Ashley Goldberg's piece and thought I'd give my own version of spring. Then Aaron seems to have taken it into winter. The dogs are part of a longer story that I've been exploring in my own artwork and I think it's funny how they were changed from vicious wolves into cute, hot-tubbing pugs. And then Jordan took them to Hell, where they probably belong.

13. **Did you create your page intending to extend Esther Pearl Watson's drawing, creating a long panorama, or did you mean to show what was going to happen next after her page? Either way, what did happen?**

ANDERS NILSEN: I wanted to extend the landscape into more of a panorama, though I think of my piece as an extension of hers, but not necessarily all of the same moment. Like, it might be a different time, in the future or past relative to the gnomes, or it might be a different place sort of superimposed. I just liked the idea of extending her landscape. I'm a sucker for an open grassy landscape, and the wider the better. And I've always loved her work. It's almost like they're different landscapes, but each gets to use the other to breathe a little more.

14. **Your page is the most visually seamless connected piece in the whole book. Can you explain how you approached your page conceptually and also how you technically got it to match so well?**

DAVID HEATLEY: I tend to overdo things in my work. In general I'm drawn to excessive, obsessive art. It's not like I was planning that mine would be the most seamless in the book. Somehow I thought everyone was going to approach their page the same way and try to get all the elements from the previous page to line up perfectly. I'm remembering now that the instructions just said to connect the horizon line of the drawing, but I must have forgotten that. When I got the drawing from Mike, I printed it out as large as I wanted to work (I think 150 percent). I taped his drawing to a wide piece of bristol and ruled out the "live" area of my drawing in pencil. I started by continuing his drawing and then free associated the rest. Later I repeated the same process in Photoshop—coloring my page alongside his as one big file, sampling the color palette he had chosen. To be honest, I was a little worried when I first saw his page because I'm not that into drawing fantasy D&D characters or superhero stuff, even in an ironic, fine art-y kind of way. So my answer was to draw this Godlike character blowing that world to smithereens (sorry, Mike… nothing personal against your terrific artwork!). I don't believe in an anthropomorphic God, but I do like the idea that God is "bigger" than anything people can create or imagine. And now I like the light bulb–head God character that I came up with, even though it has nothing to do with how I think God actually functions in the world (i.e., as an entity deciding things, manipulating events, controlling people's lives). Maybe I'll make a vinyl toy of Him someday, though He probably needs a comic strip vehicle or Saturday morning cartoon first… Stay tuned!

15. The beast in Irina Troitskaya's piece, before yours, seems happy strolling through the forest with his four-legged bird friend; what happened to make it so thirsty for blood?

BEN FINER: The real question is why the creature wasn't hungry for blood in the previous panel. Blood is a nutritious, iron-rich part of a correctly balanced diet, especially for large carnivorous mammalians. One would actually be hard pressed to find a creature of the dimensions presented in the previous panel that wasn't spending most of its waking hours searching to quench its unrelenting thirst for blood. Animals don't have the luxury of popping down to the local Atlantic & Pacific Mega-Supermarket to buy blood willy-nilly. Many animals barely use money. Those that do aren't sensible enough to buy blood; most just spend it on expensive cigars. (I believe the Atlantic & Pacific Mega-Supermarkets no longer carry vats of blood for this specific deficit in demand.) So the question remains: Why was this creature casually meandering through the forest without a care in the world, ignoring its base desires to fill its belly with thick, rich bloody sustenance, allowing a mutated bird to dig its multiple talons into the soft flesh of its ample hide? The answer, I am sorry to report, is that this animal was high on methamphetamine.

16. What is the title of your piece?

CHRIS KYUNG: *You Will Die Before You Can Cry Forever.*

17. You took a really narrative approach to creating your page. Before seeing Vanessa Davis's page, what would you imagine happens to the main character in the next scene?

JOEL TRUSSELL:

A. shoots the bird.

B. uses the sleeping pills as ear plugs.

C. blows his tormented face off.

D. orders a pizza.

E. updates his Facebook status.

F. both A and D.

G. none of the above.

18. You have a gang of small animals running through your page. Where did you imagine they would be going next?

MEG HUNT: If I were to continue things, they would scamper off from the mountains and figure a way to build a suitable sailing apparatus for adventure. They feel as though they're ready for a strange little quest, so I bet there would be a boat cobbled from twigs and leaves and shells and such.

19. Your piece was specifically labeled so we could identify the women's heads on the beast. Who are these women and why did you choose to paint them?

CATELL RONCA: In searching how to respond to Alyson Fox's image I was very intrigued by the multiheaded female figure in her piece. I wanted to do something with it, so I looked at the origins of a multiple-headed creature. Not surprisingly, the most famous one is to be found in Greek mythology. The Lernean Hydra is a beast with nine heads, and every man who tried to kill it failed miserably. As soon as one head is severed, two more take its place.

I then asked myself what would be a modern-day female Hydra? What form of evil seems to regenerate itself every time it is fought? That's when I came up with the idea of women terrorists. Also, this phenomenon is sometimes glorified, certainly in the cases of Ulrike Meinhof and Leila Khaled.

The image I created is a collection of portraits of female terrorists, some still alive, some dead, from around the world, all of whom have caused (or tried to cause) death to others. This aspect also refers back to the coffins in Alyson's image. In a perhaps morbid way, I felt compelled to communicate this aspect of modernity—female aggression.

20. Who is the woman shown in your painting? Why did you decide to depict her?

JAMES JEAN: After seeing the Hydra in the previous panel, I thought it might be relevant to "zoom in" and examine a single portrait. Playing off of the headscarves in the piece by Catell Ronca, I found an old picture of a nun from a thrift store. The photo was anonymous, undated, and abandoned. If Catell's piece was a sort of family tree of terrorists, then my piece would be a pious orphan.

HOW TO READ THIS BOOK

Each chapter contains artwork by ten artists. Their names are listed sequentially in the chapter opener. The first five artworks are shown on the front of the accordion page, and the following five on the reverse side.

KATY
HORAN

SIMON
EPLOW

JEN
ORACE

PABLO
MARGO

MEL
KADEL

RYAN
JACOB
SMITH

AJ
PURDY

E LITTLE
ENDS OF
NTMAKING

CRAIG
TKINSON

ARSON
ELLIS

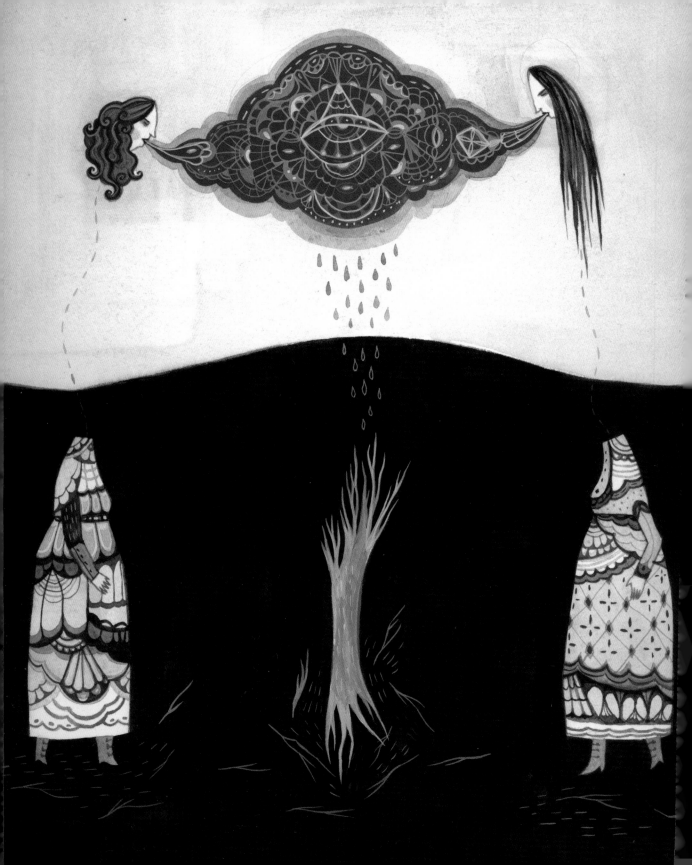

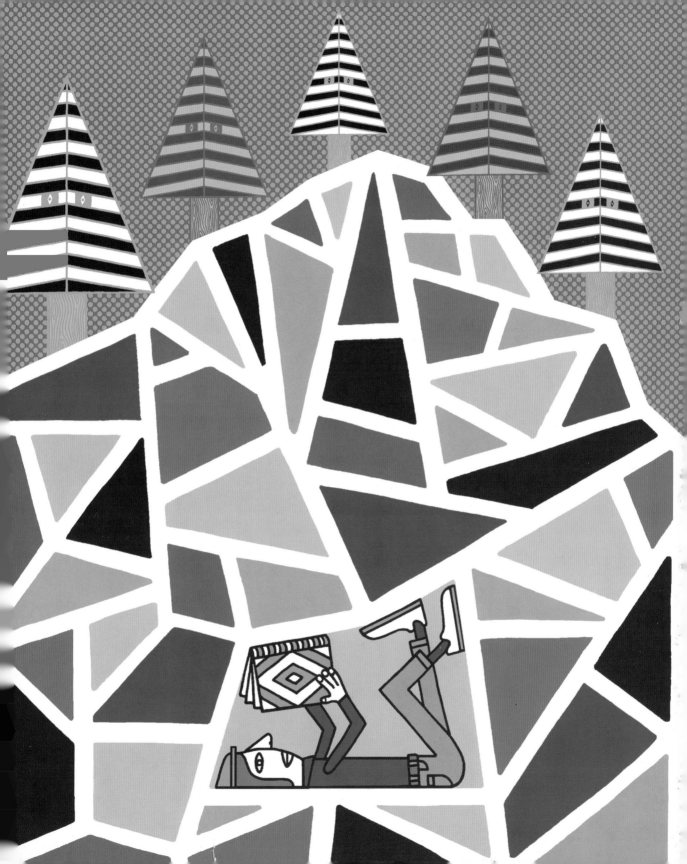

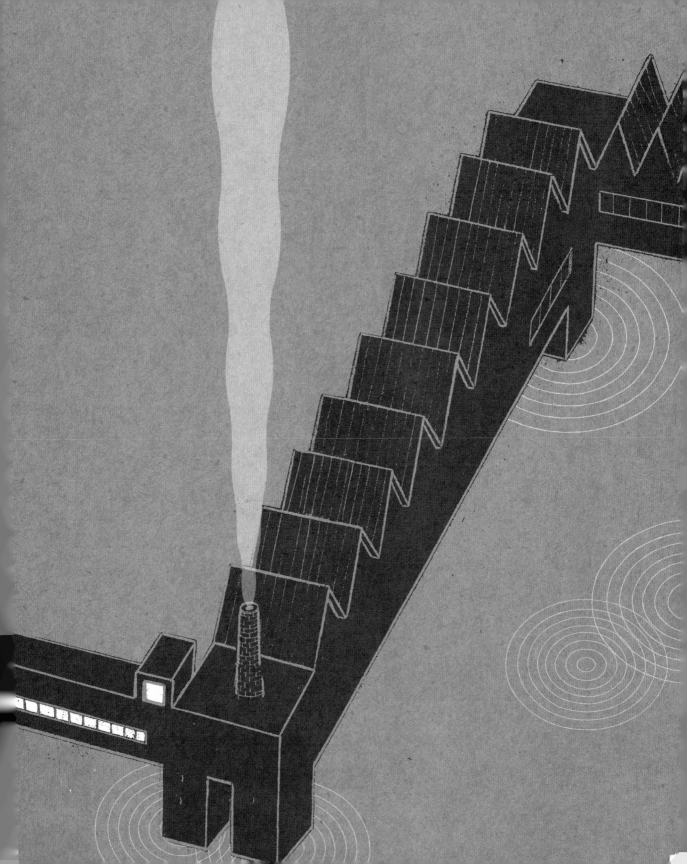

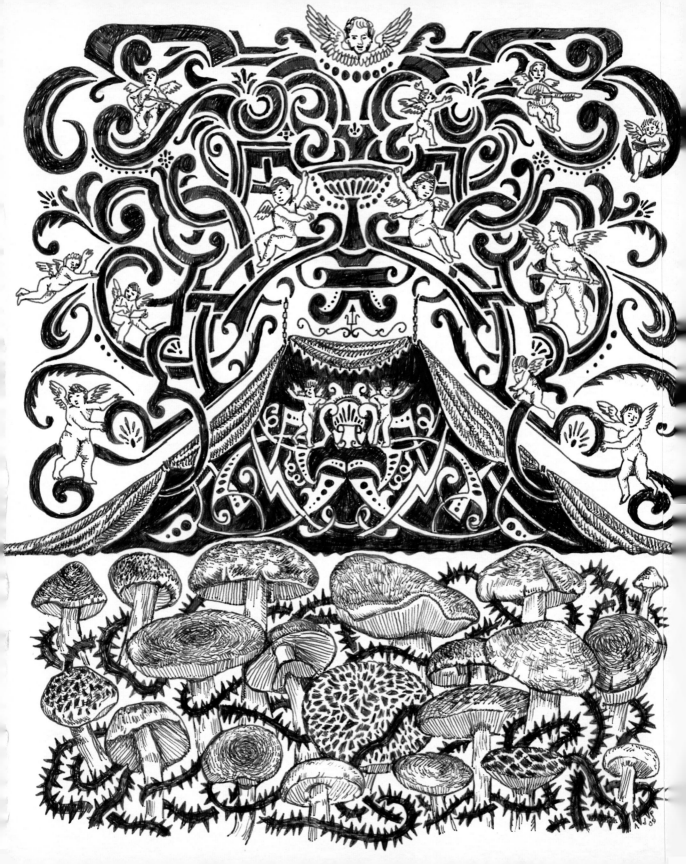

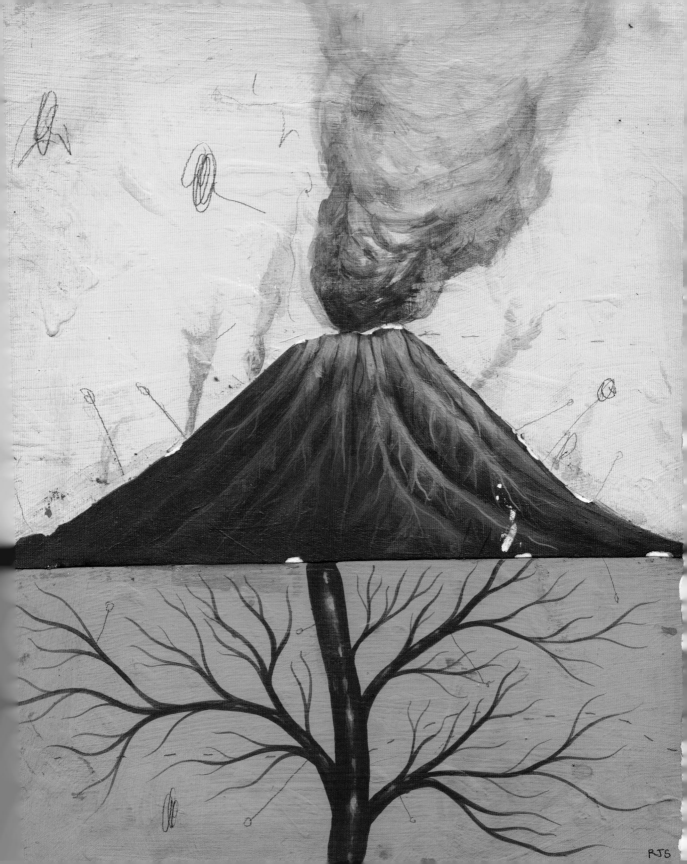

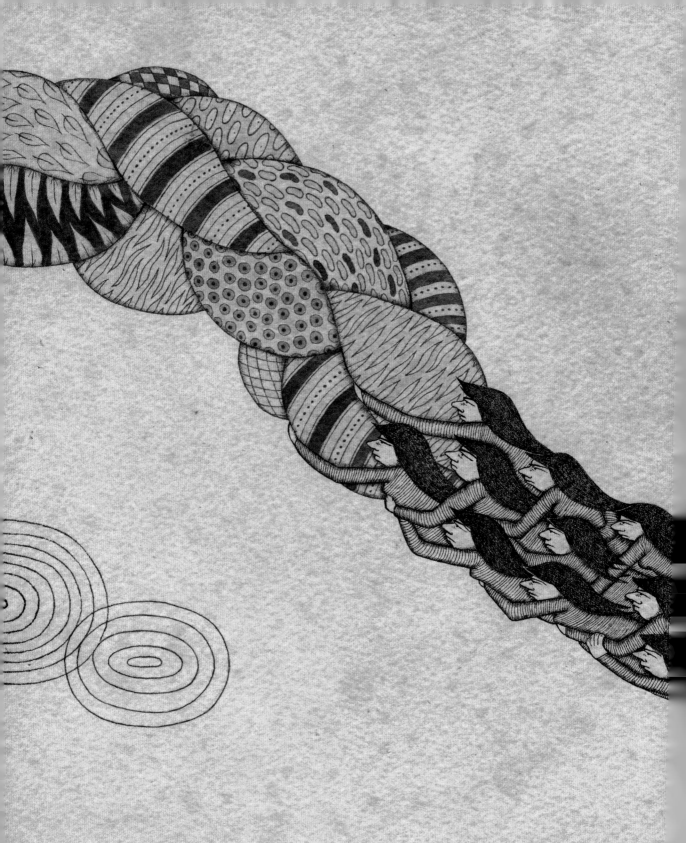

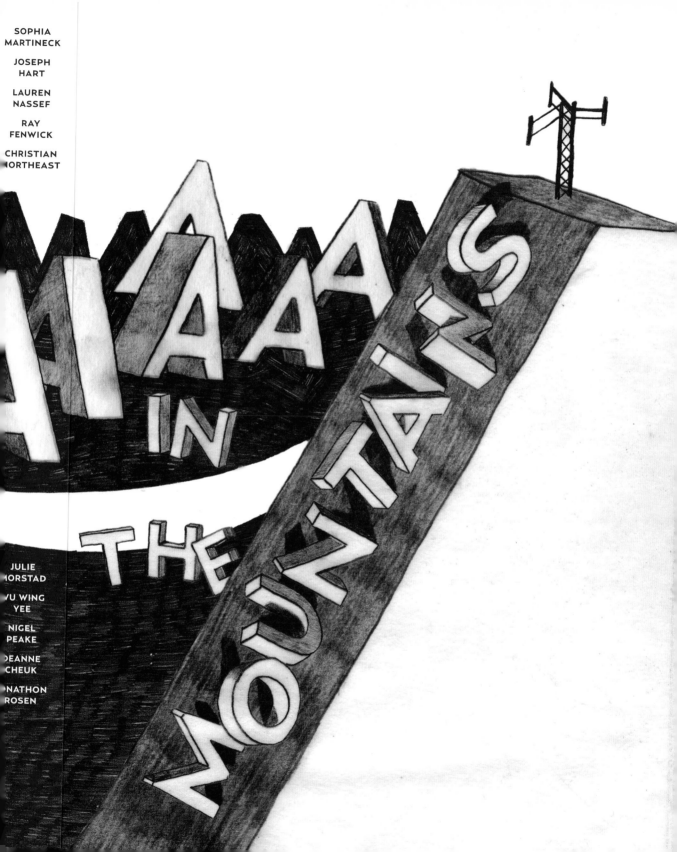

SOPHIA
MARTINECK

JOSEPH
HART

LAUREN
NASSEF

RAY
FENWICK

CHRISTIAN
NORTHEAST

JULIE
MORSTAD

WU WING
YEE

NIGEL
PEAKE

DEANNE
CHEUK

JONATHON
ROSEN

HAAAS IN THE MOUNTAINS

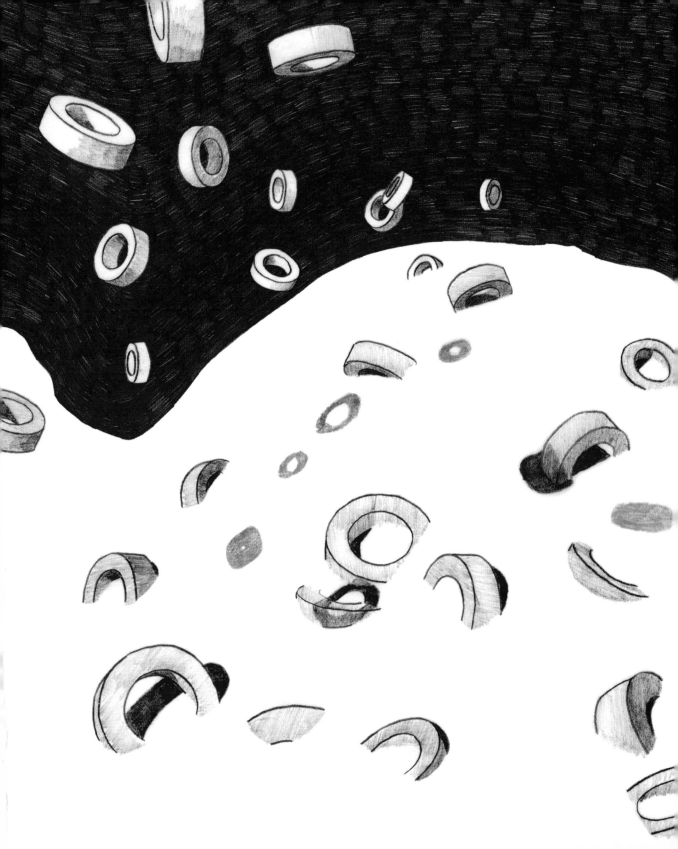

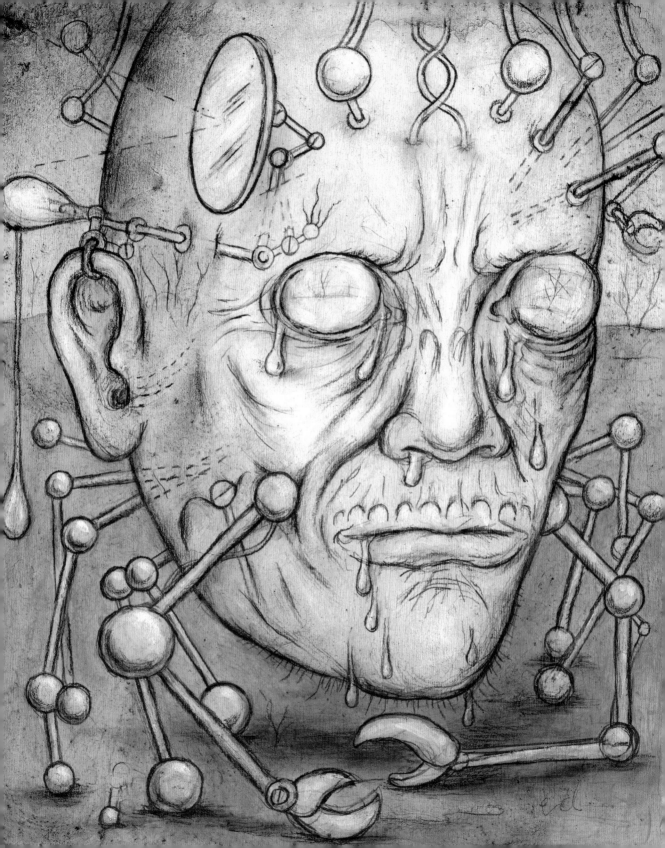

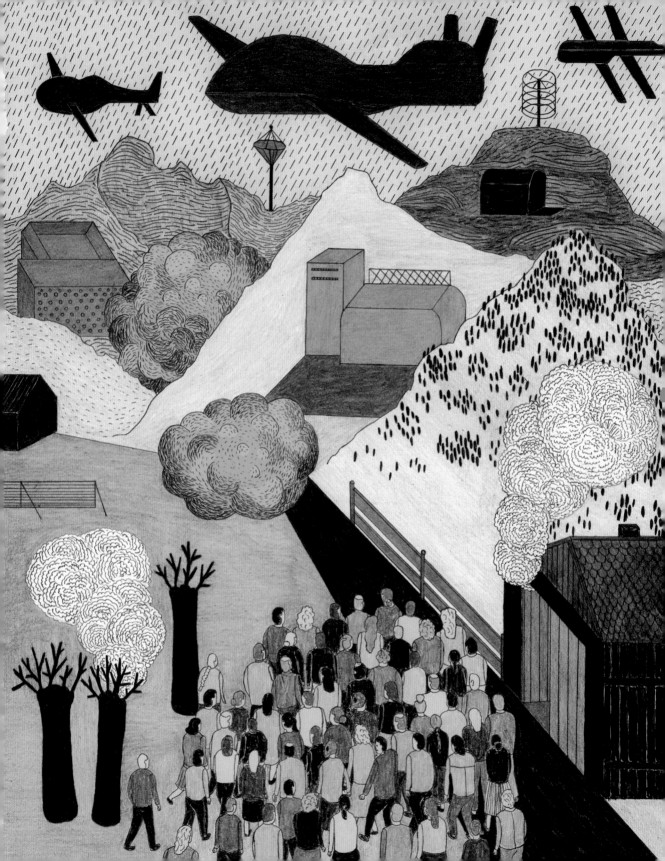

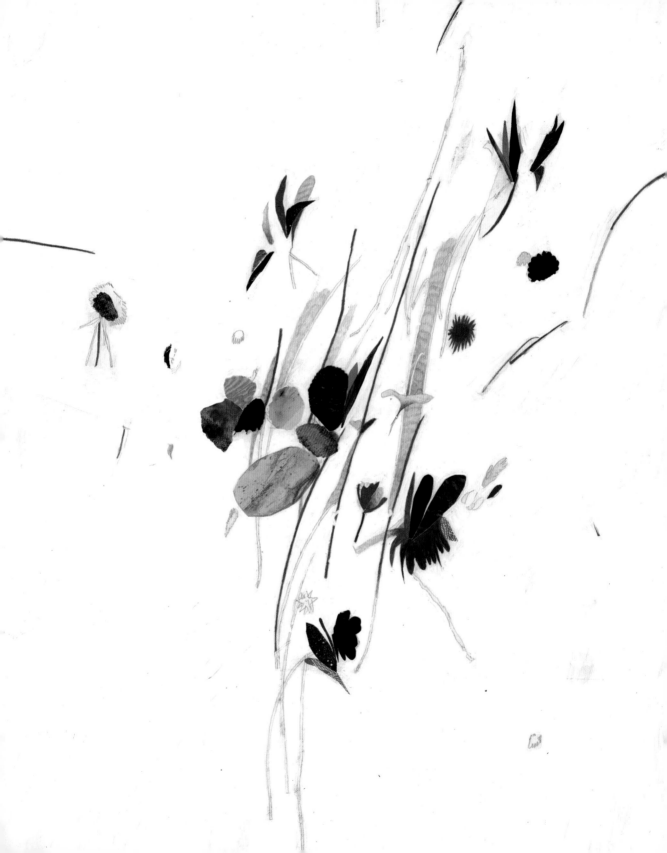

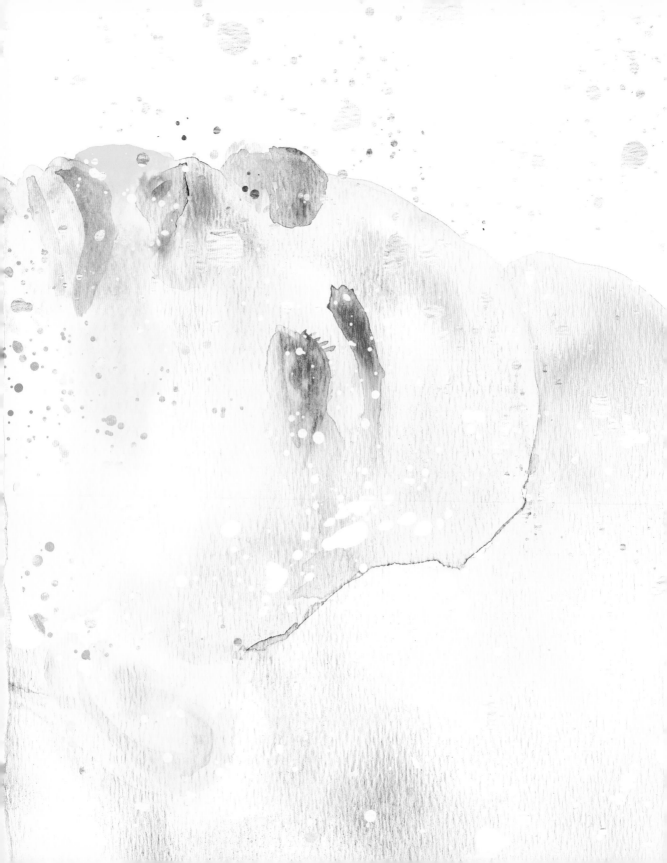

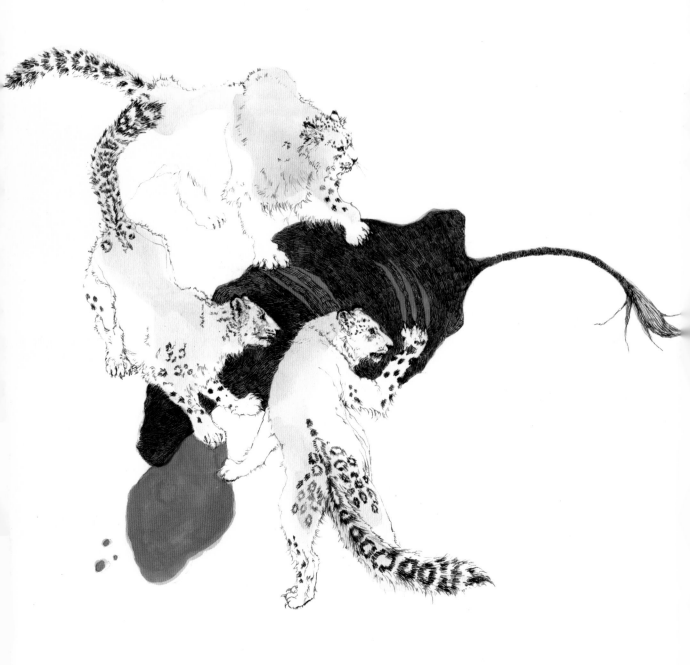

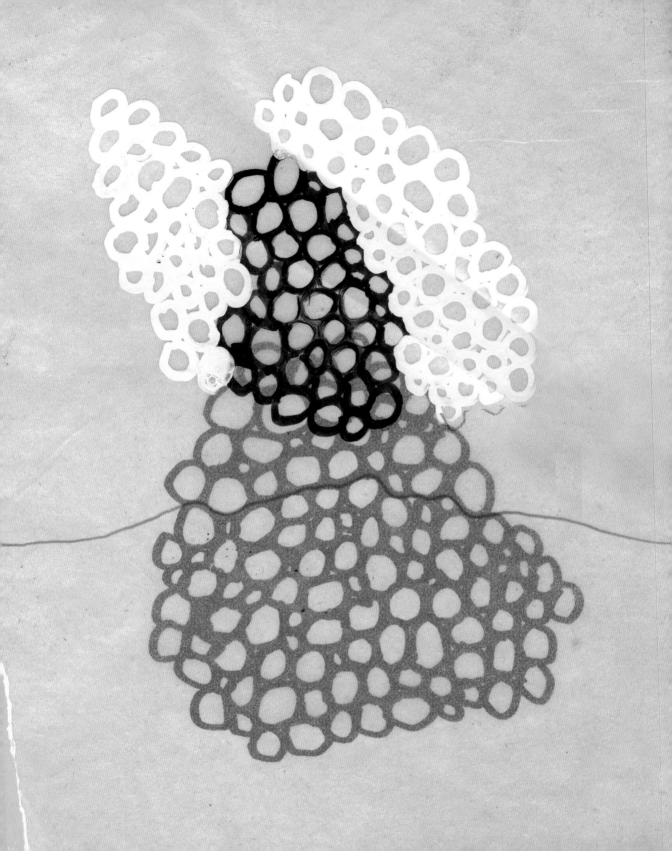

MATT
LEINES

WARD
ZWART

THE HEADS
OF STATE

LILLI
CARRÉ

BRIAN
REA

CARMEN
SEGOVIA

DAVID
SHRIGLEY

BRIAN
CRONIN

JENNIFER
DANIEL

JULIA
ROTHMAN

IN THE SNOW

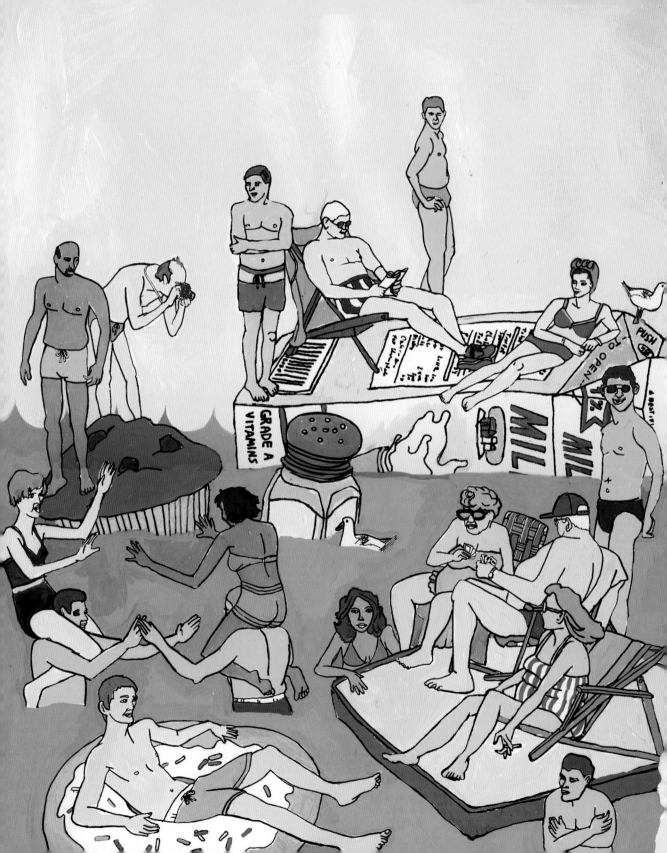

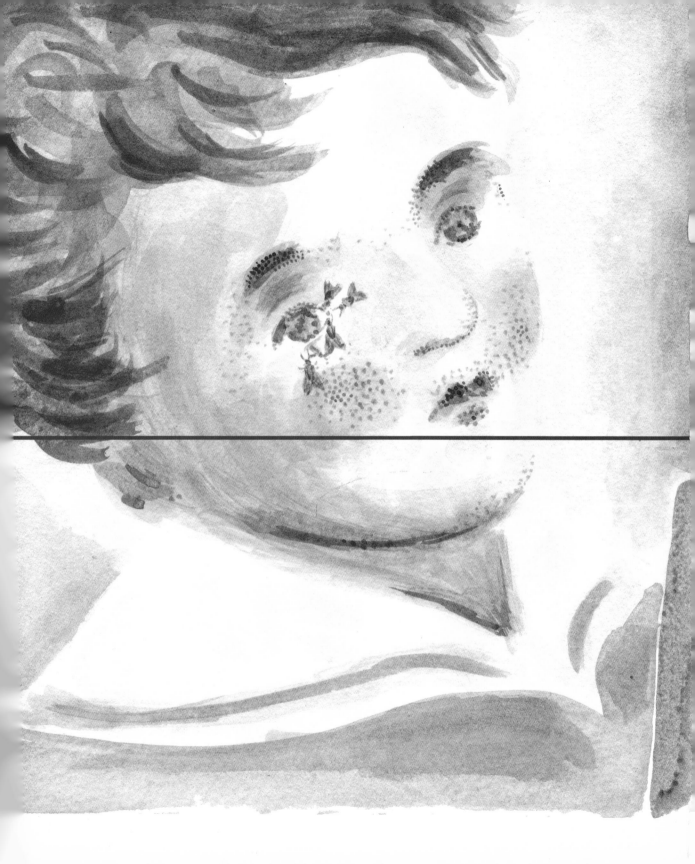

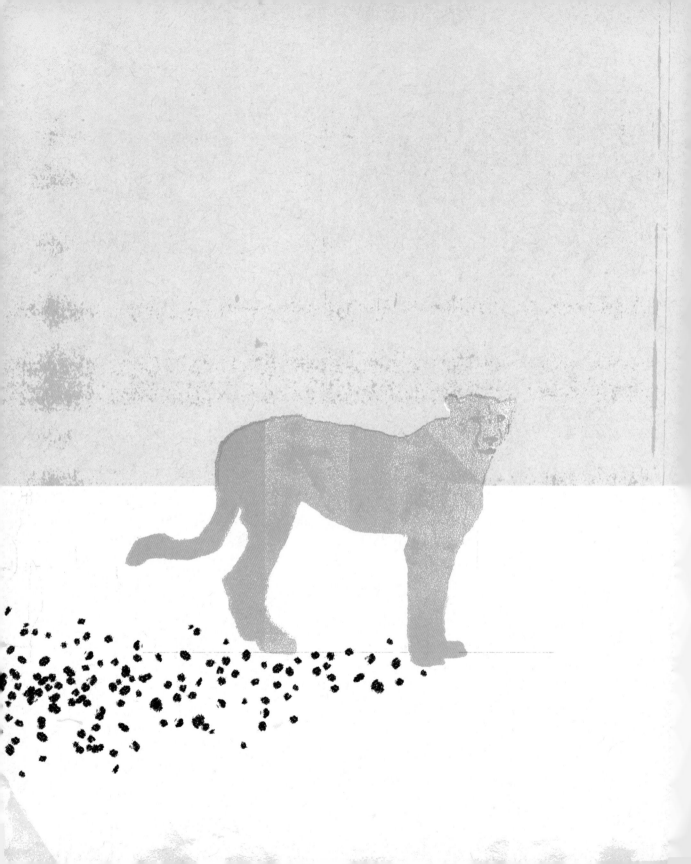

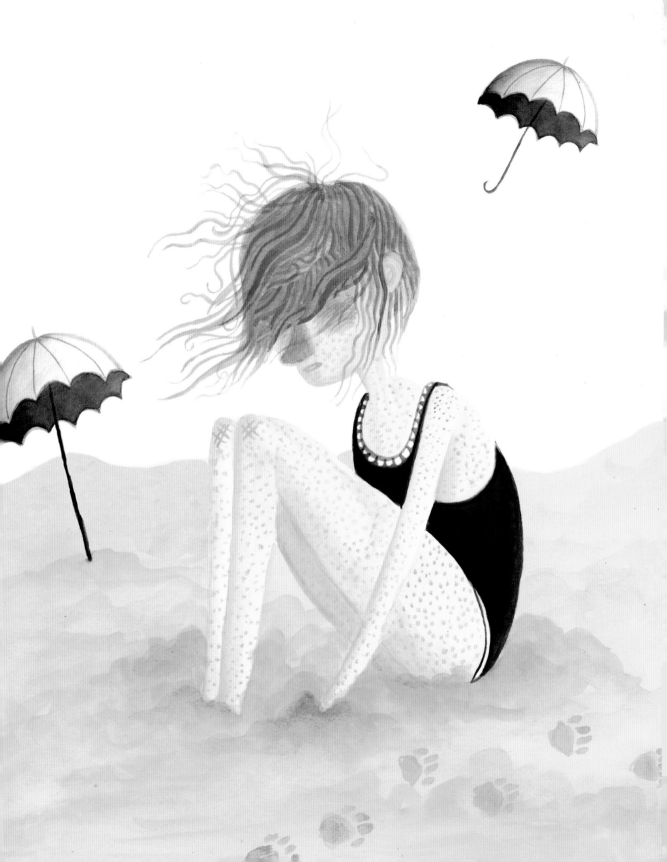

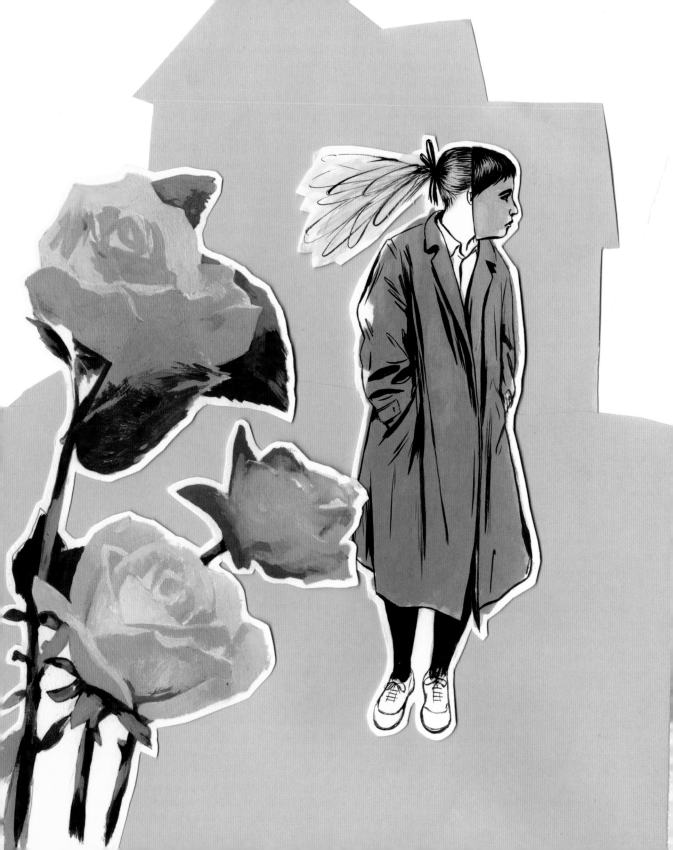

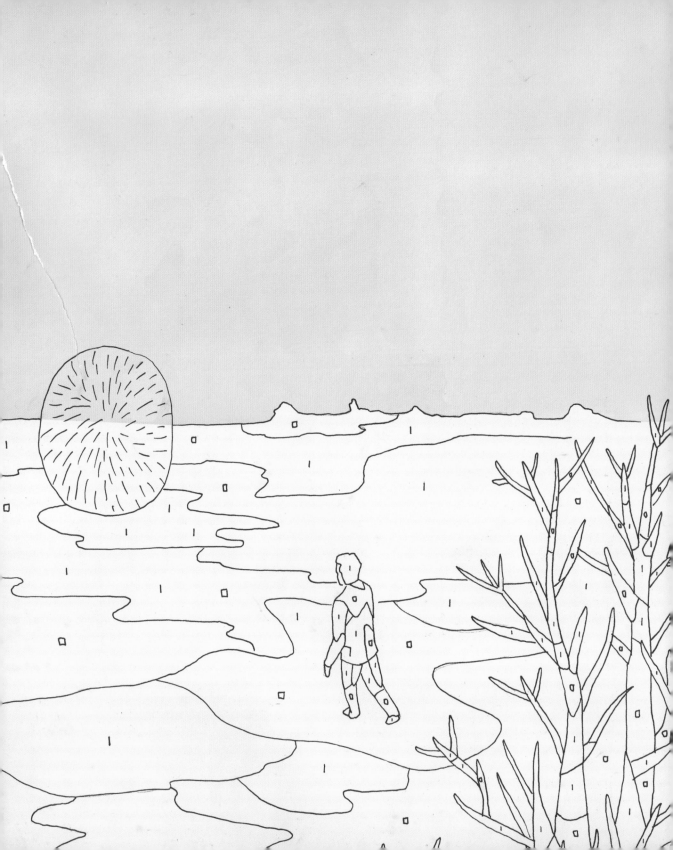

TAKASHI
IWASAKI

HARRIET
RUSSELL

SARAJO
FRIEDEN

ZACH
KANIN

MEG
HUNT

ARTHUR
JONES

LENA
SJOBERG

MIKE
LOWERY

ELLIE
CURTIS

LORENA
IMINOVICH

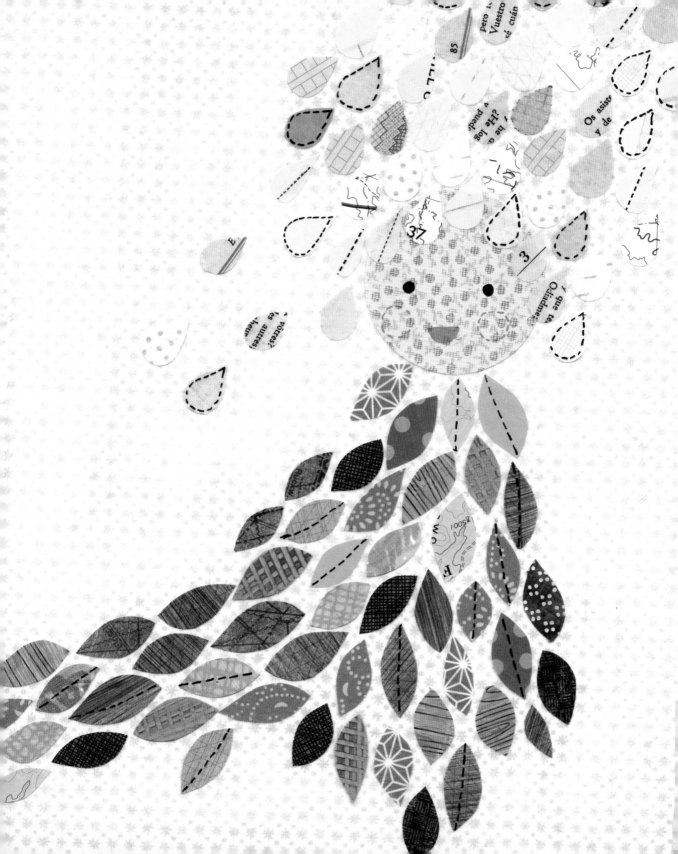

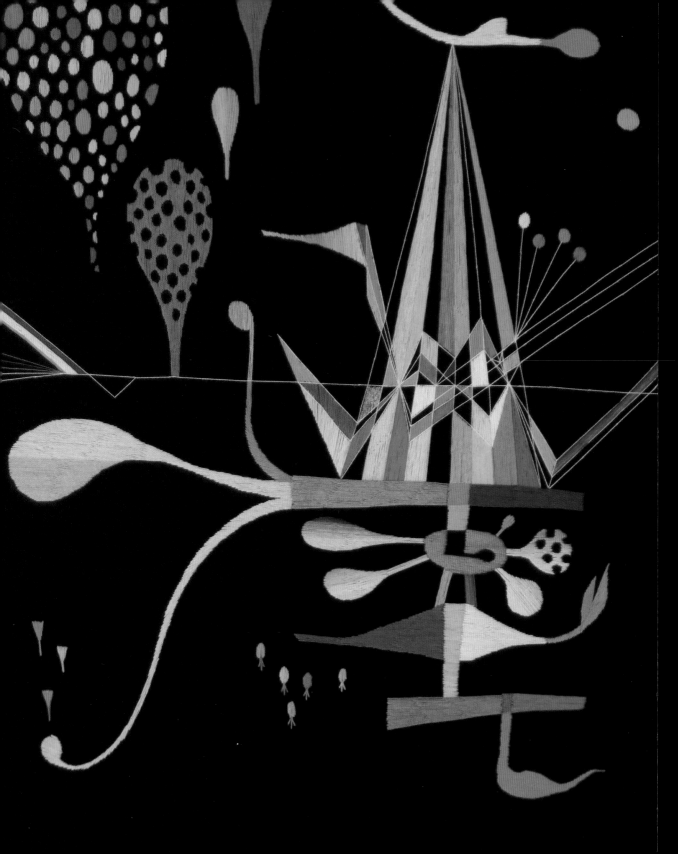

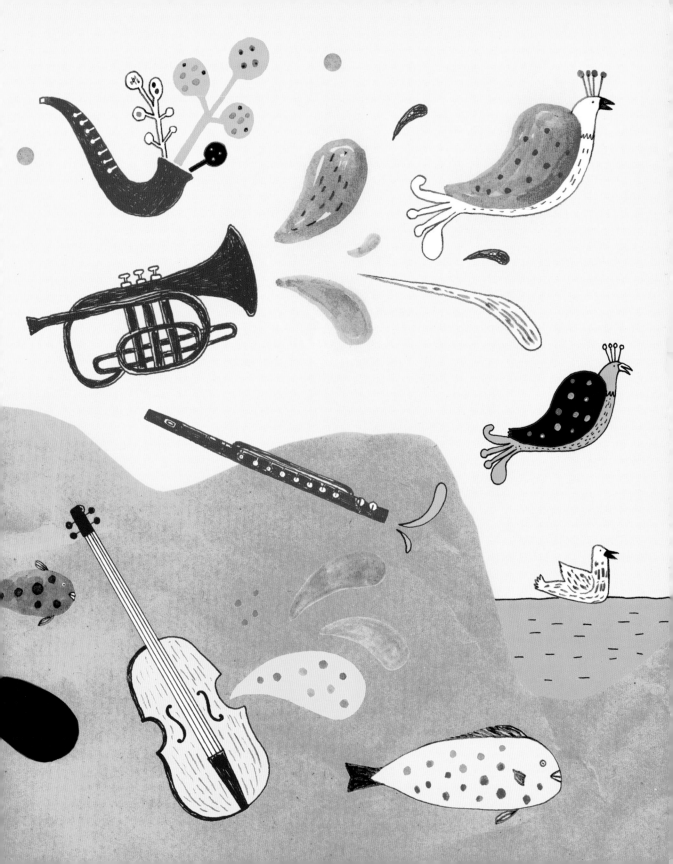

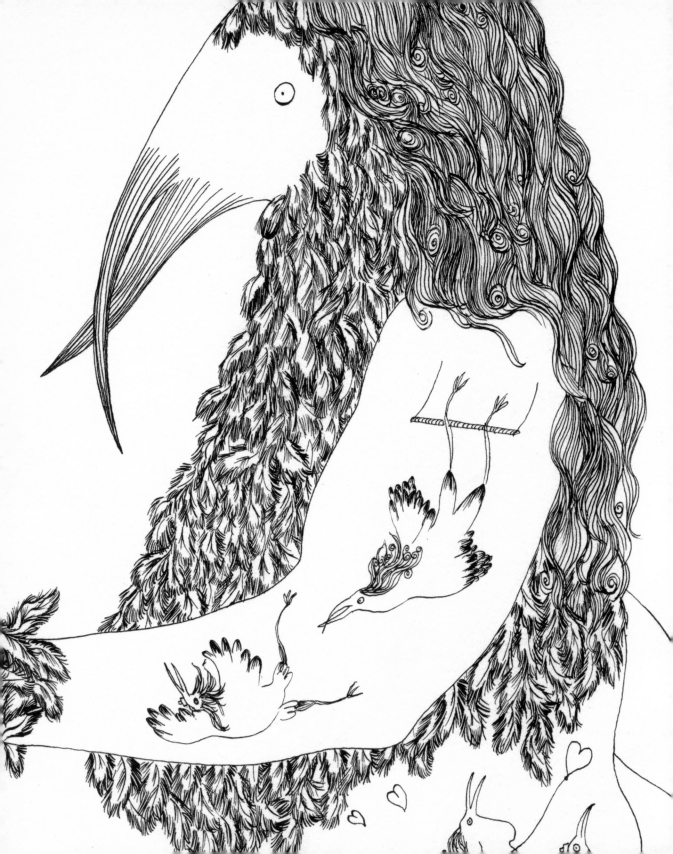

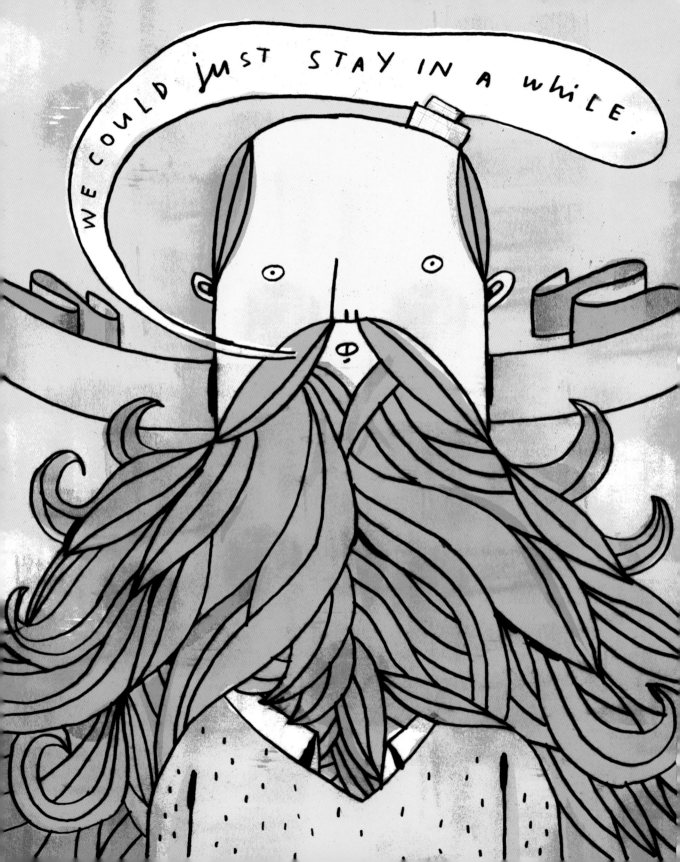

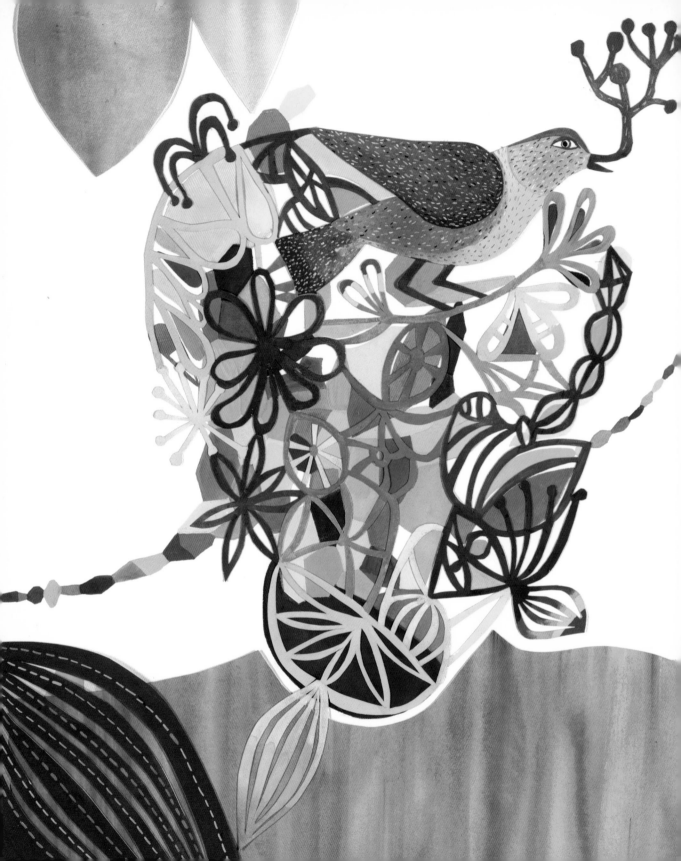

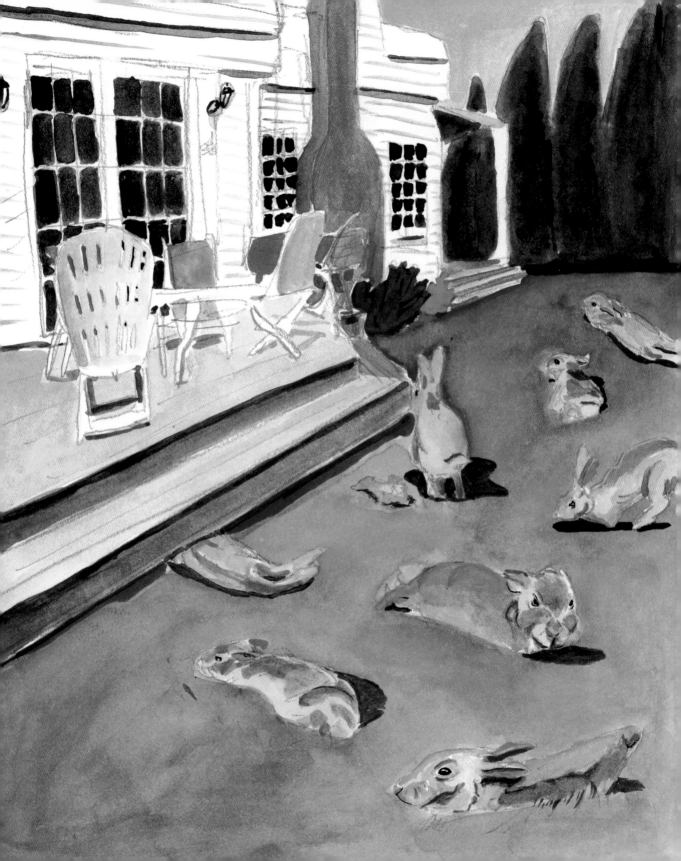

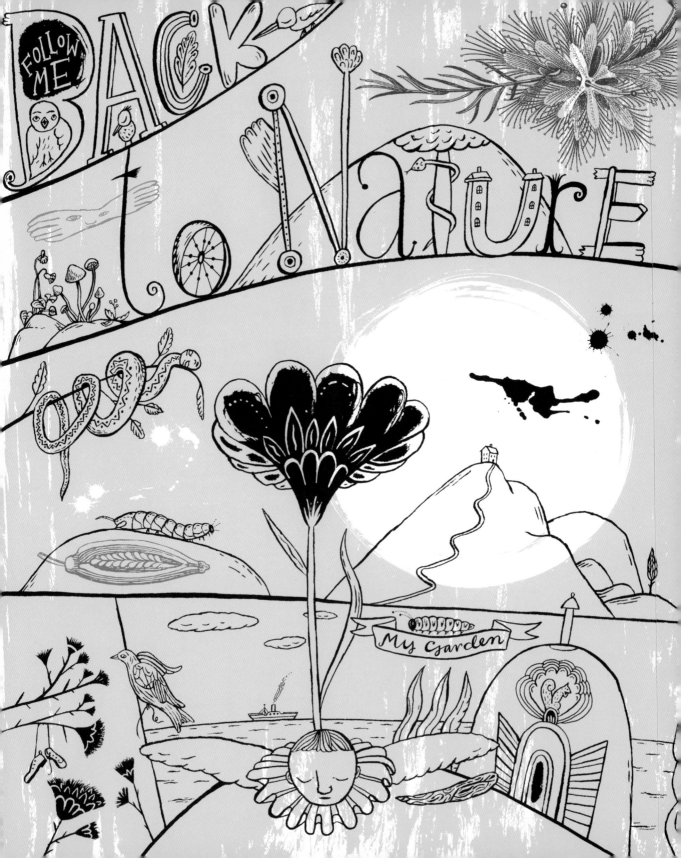

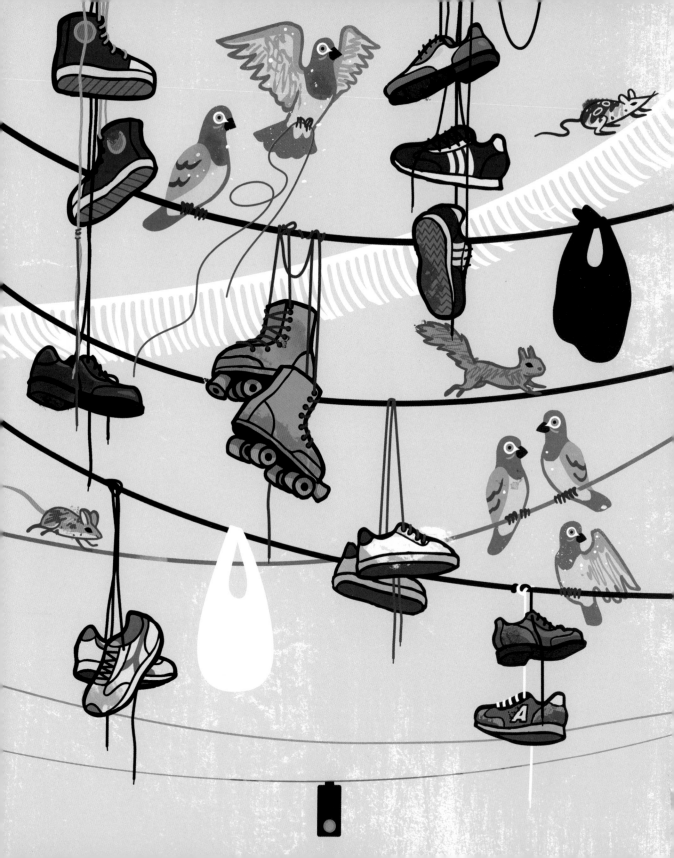

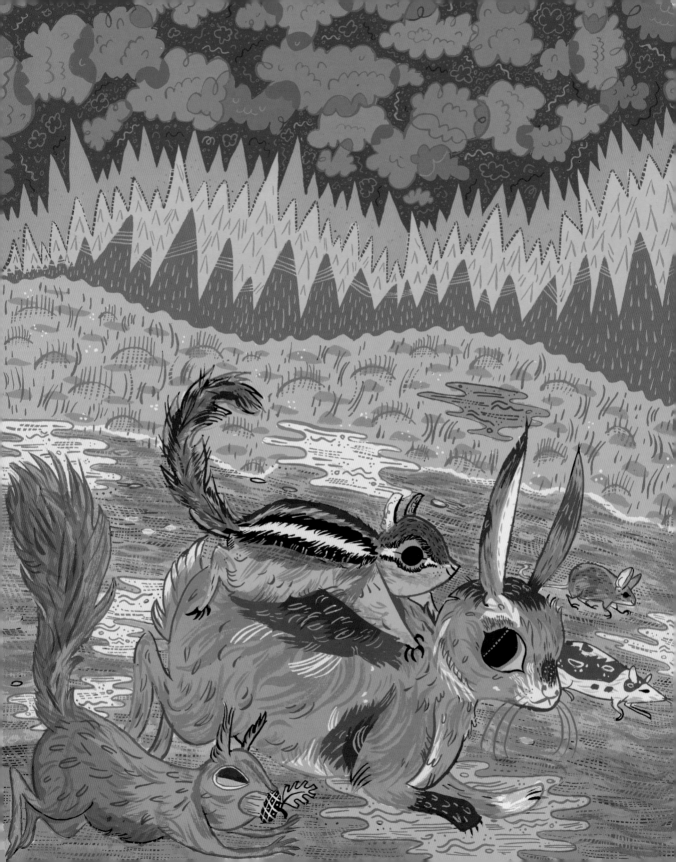

ELINDA
BECK

LIETTE
ORDA

MIKE
ERRY

MILLA
GMAN

LAB
RTNERS

NICK
EWAR

LEIF
RSONS

LIANO
ONZI

BOUR

NING
NBRETH

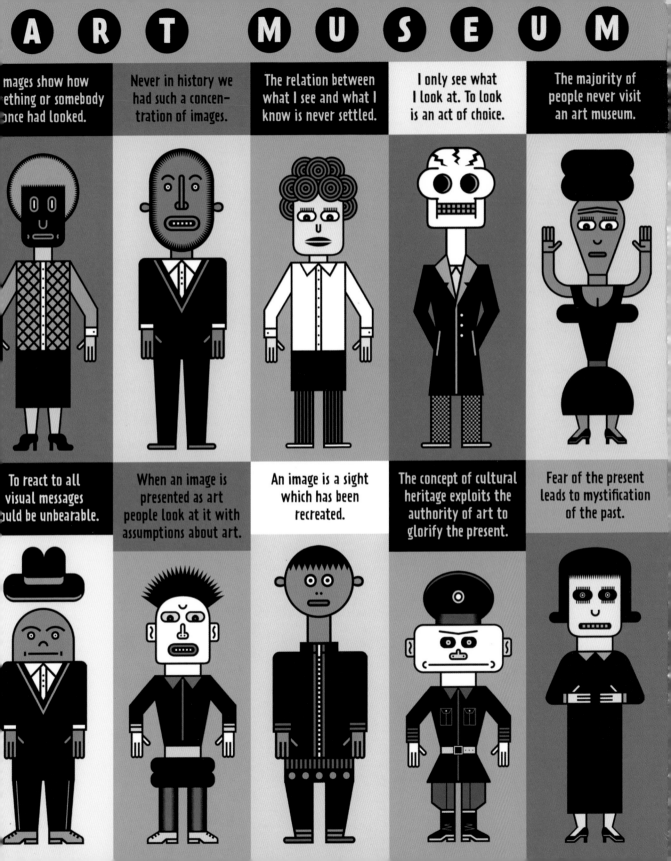

A R T M U S E U M

mages show how ething or somebody nce had looked.

Never in history we had such a concentration of images.

The relation between what I see and what I know is never settled.

I only see what I look at. To look is an act of choice.

The majority of people never visit an art museum.

To react to all visual messages uld be unbearable.

When an image is presented as art people look at it with assumptions about art.

An image is a sight which has been recreated.

The concept of cultural heritage exploits the authority of art to glorify the present.

Fear of the present leads to mystification of the past.

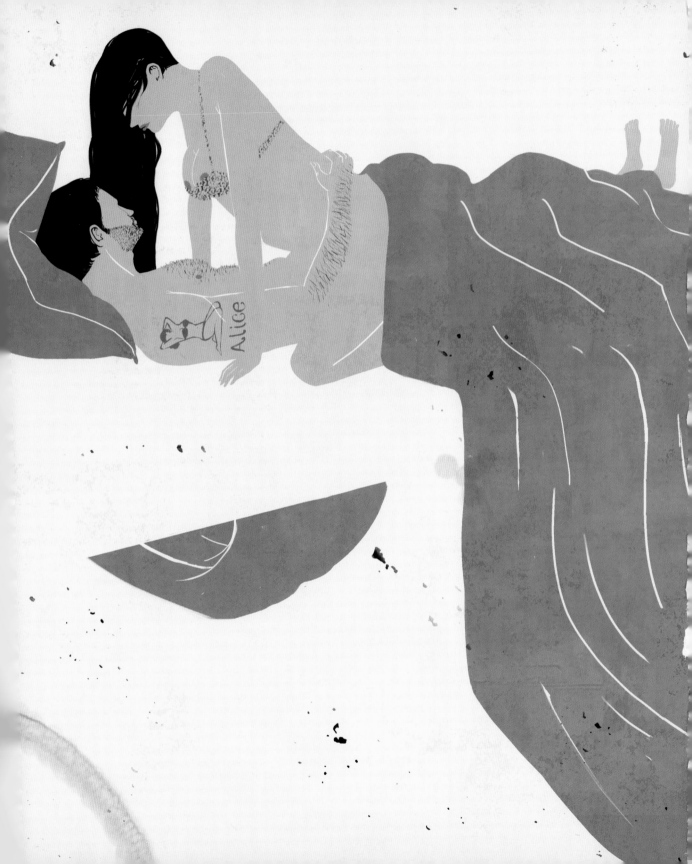

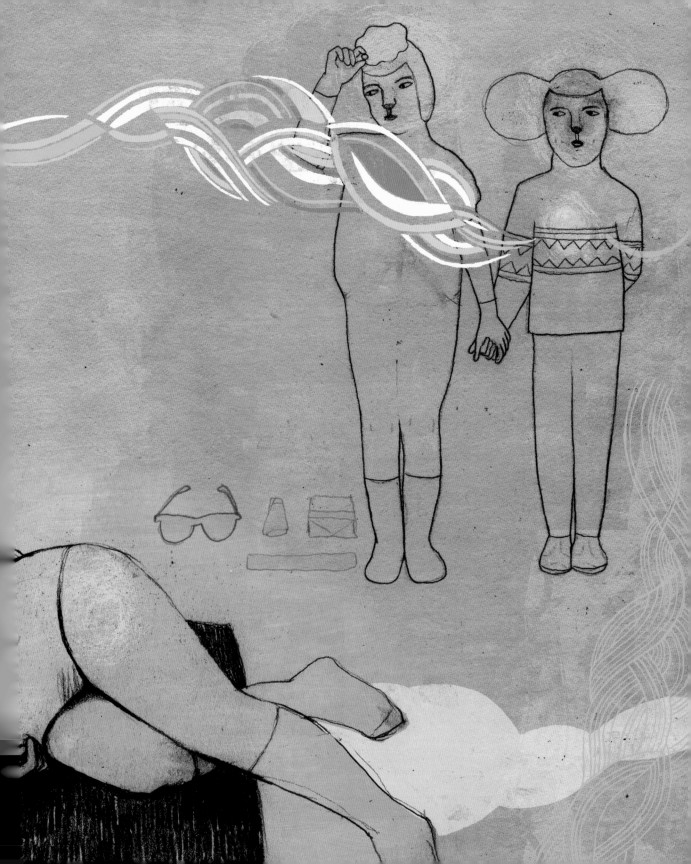

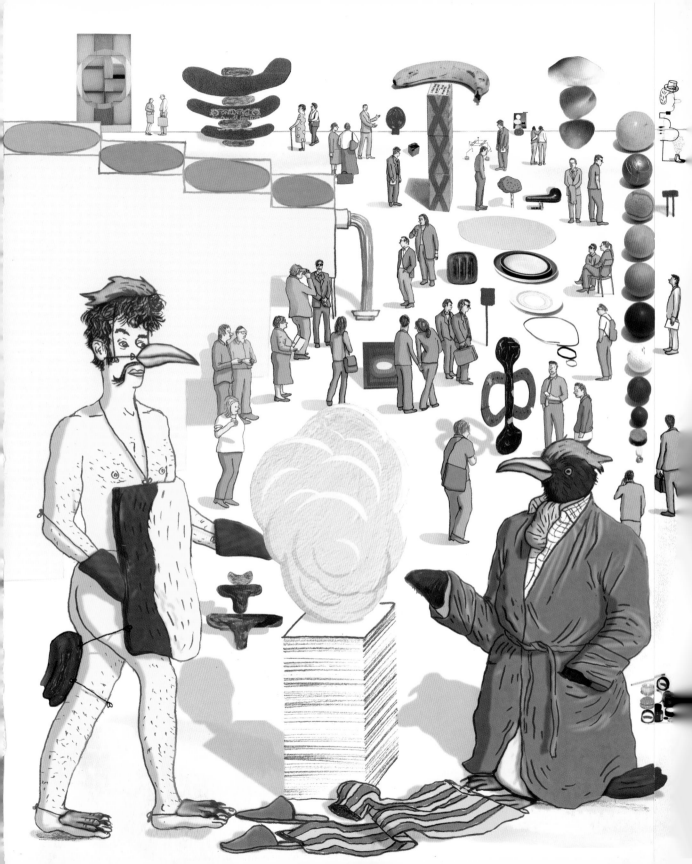

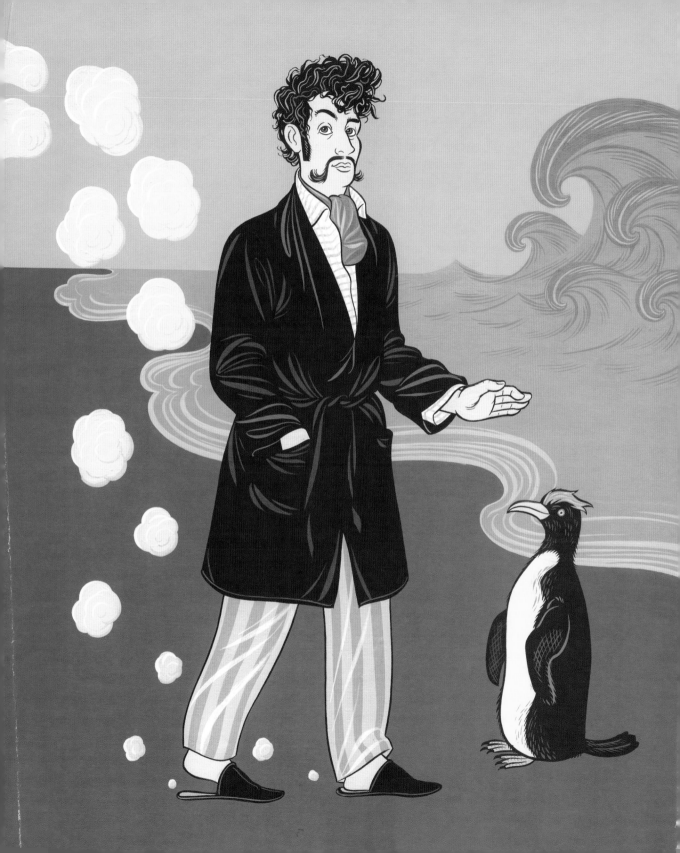

IN THE CITY

AUSTIN
ENGLISH

EUNICE
MOYLE

LAURA
JUNGKVIST

CLAUDIA
PEARSON

JULIA
POTT

MIKEL
CASAL

JOEL
RUSSELL

VANESSA
DAVIS

AXWELL
LOREN
HOLYOKE-
HIRSCH

EDIE
FAKE

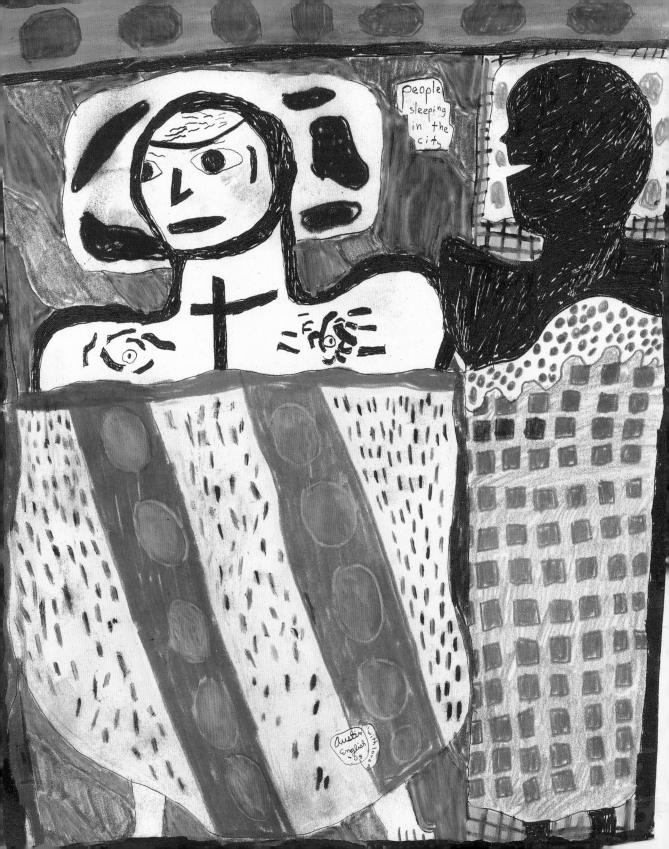

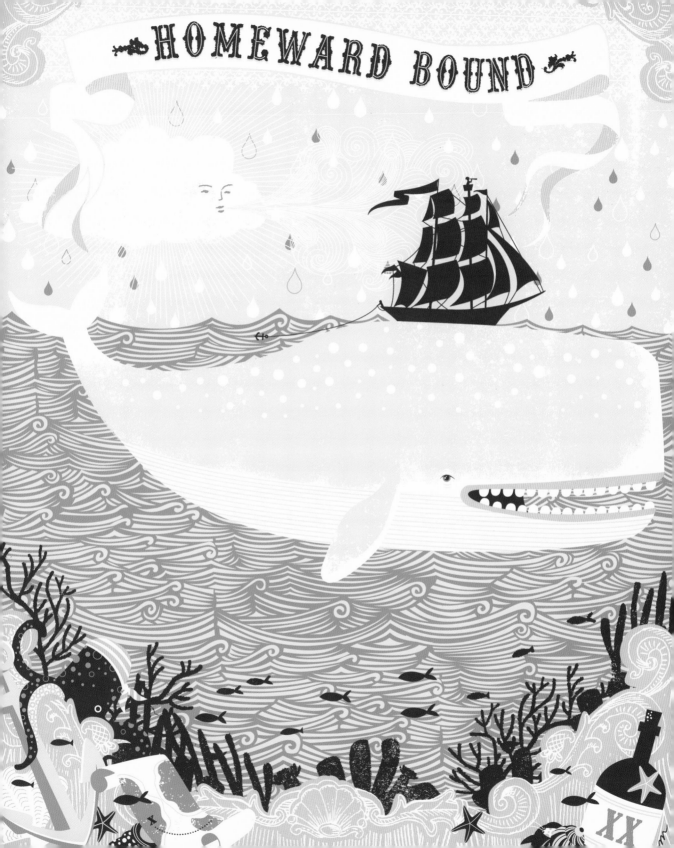

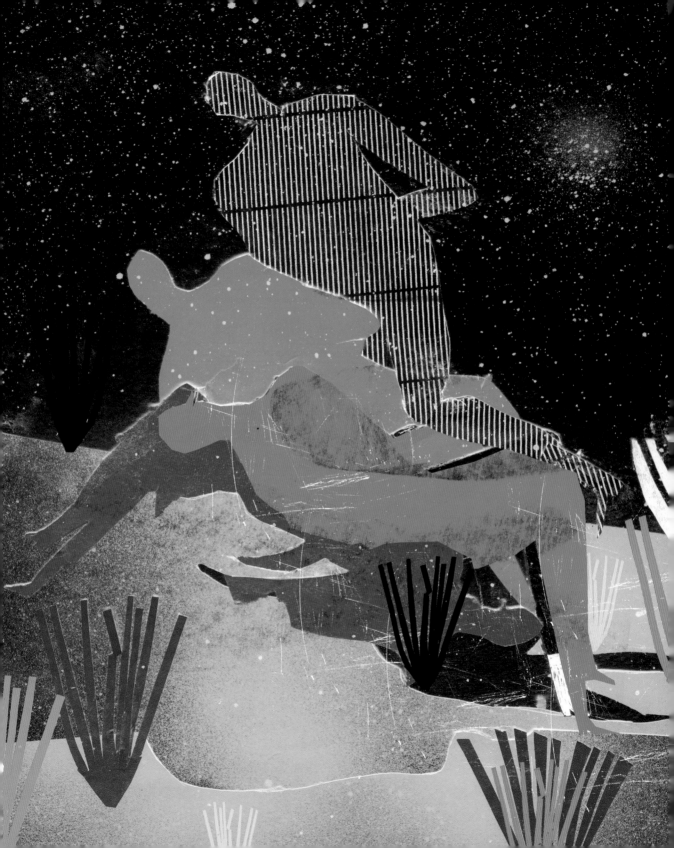

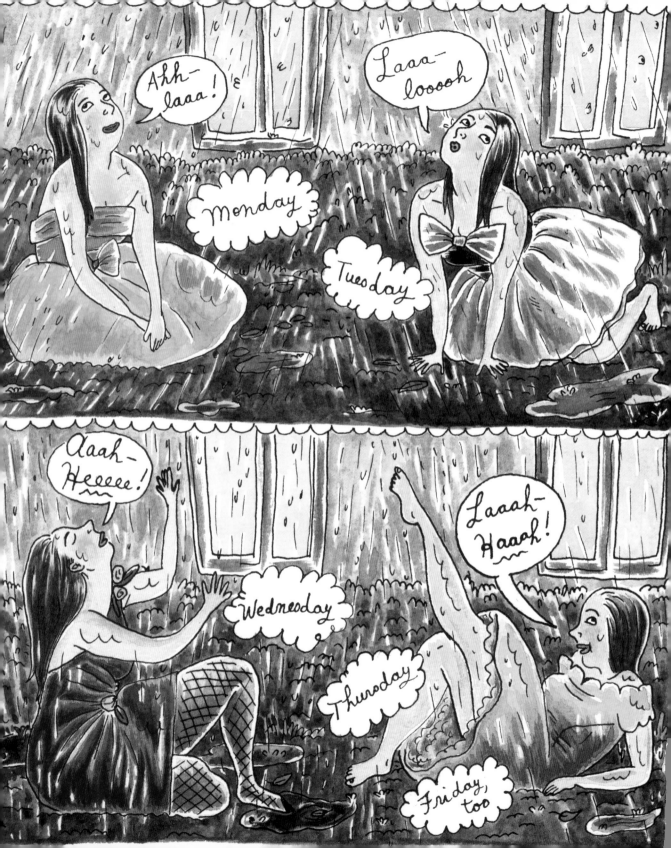

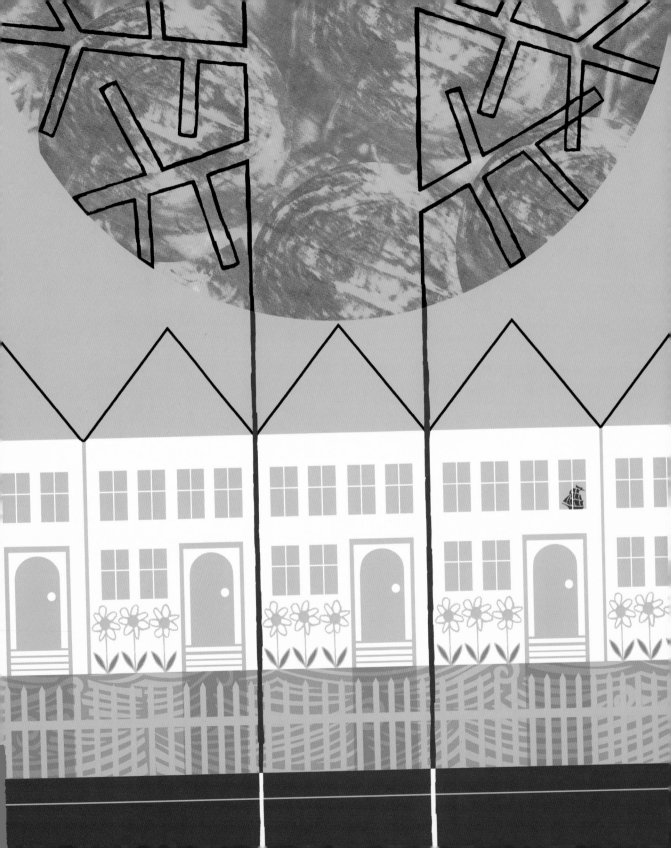

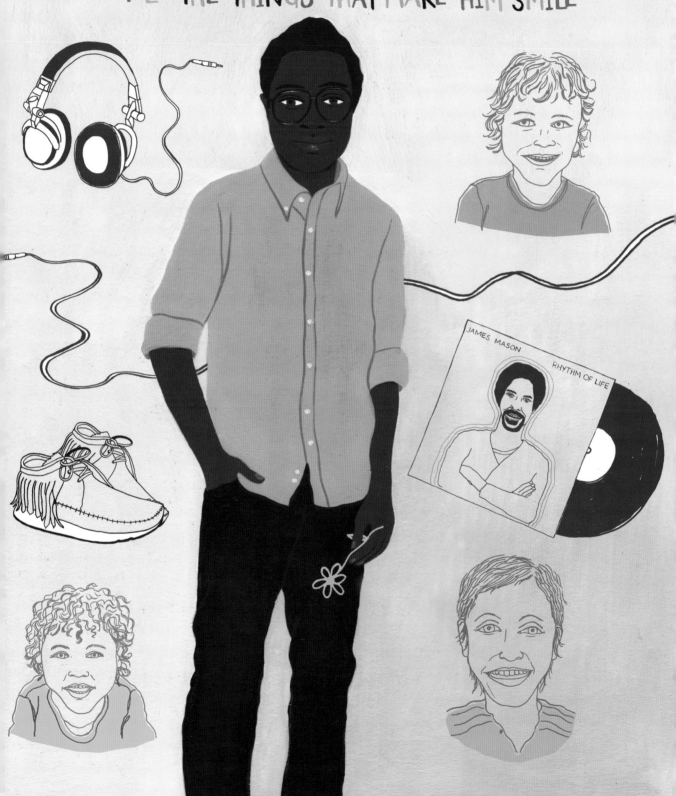

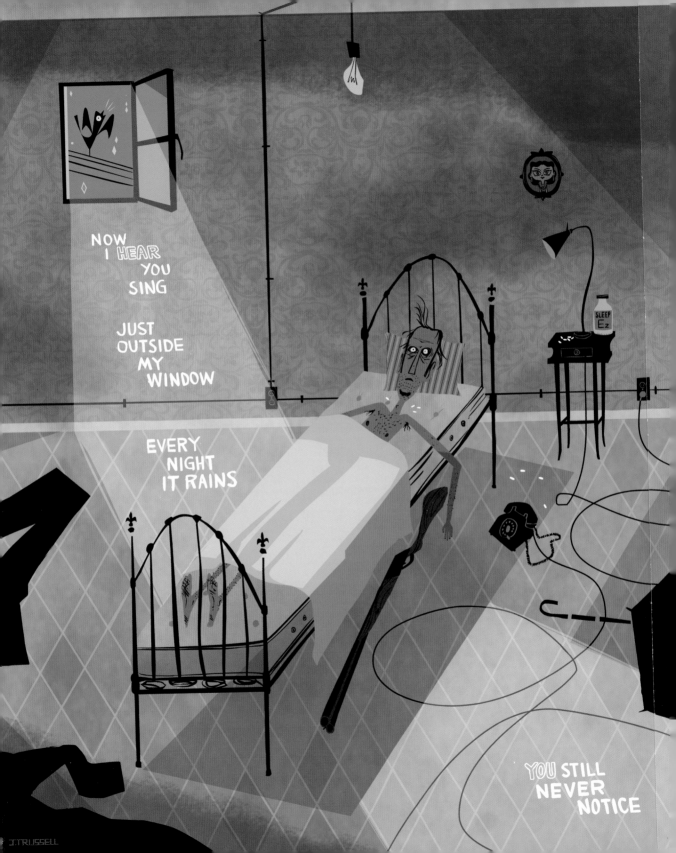

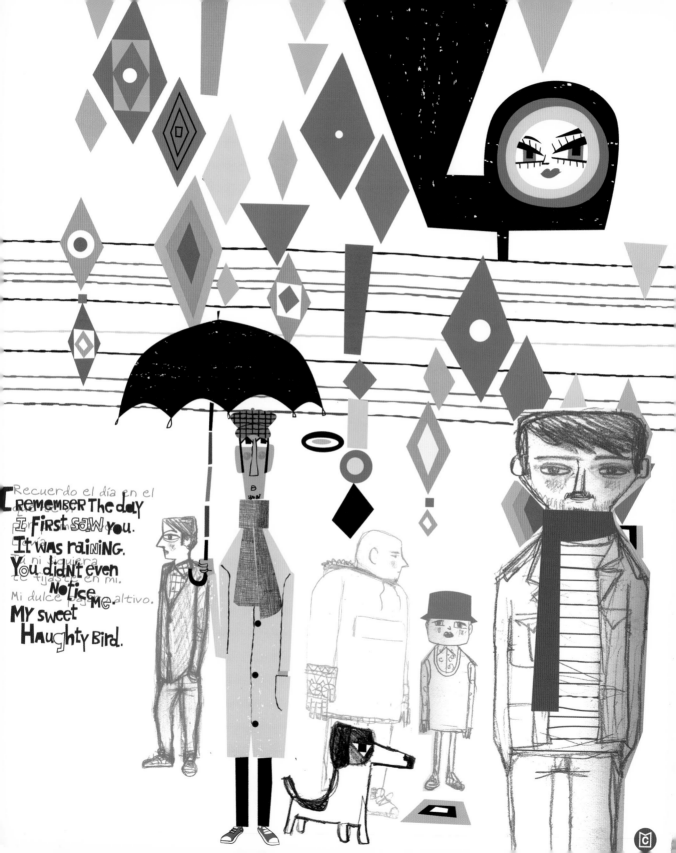

Recuerdo el día en el
I REMEMBER THE DAY
I FIRST saw you.
It was raining.
Tú ni siquiera
You didn't even
te fijaste en mí.
NOTICE ME.
Mi dulce pájaro altivo.
MY sweet
HAUGHTY bird.

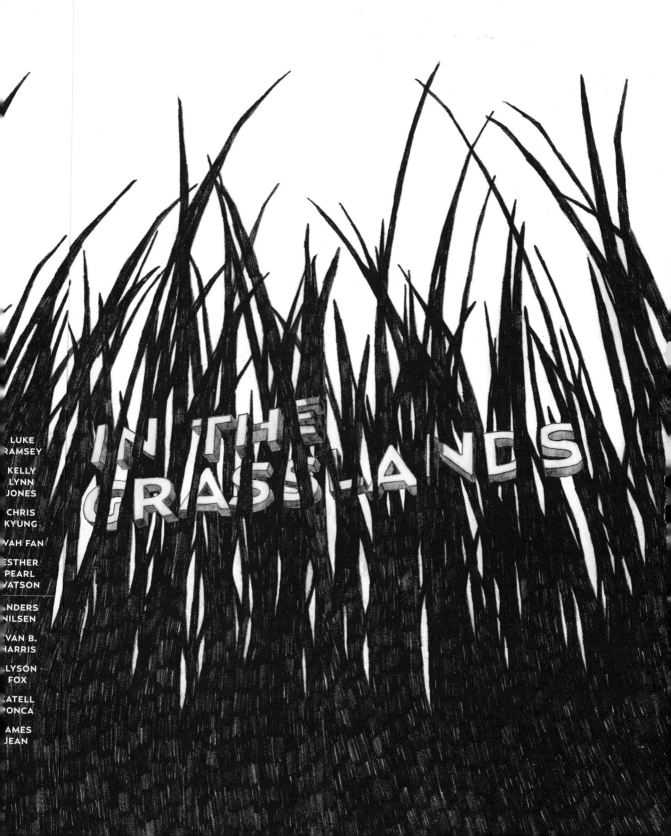

LUKE
RAMSEY

KELLY
LYNN
JONES

CHRIS
KYUNG

VAH FAN

ESTHER
PEARL
WATSON

ANDERS
NILSEN

VAN B.
HARRIS

LYSON
FOX

ATELL
ONCA

AMES
JEAN

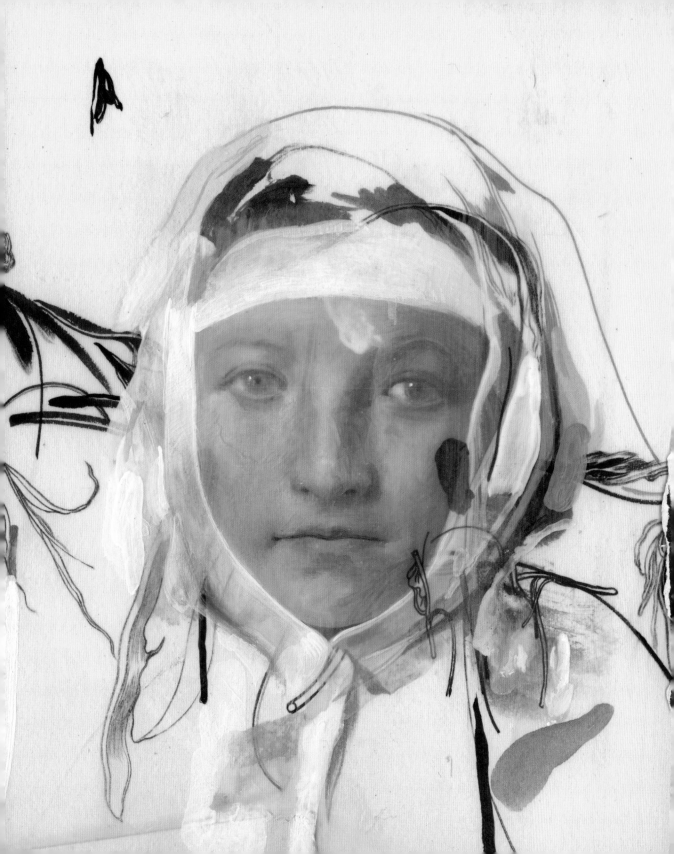

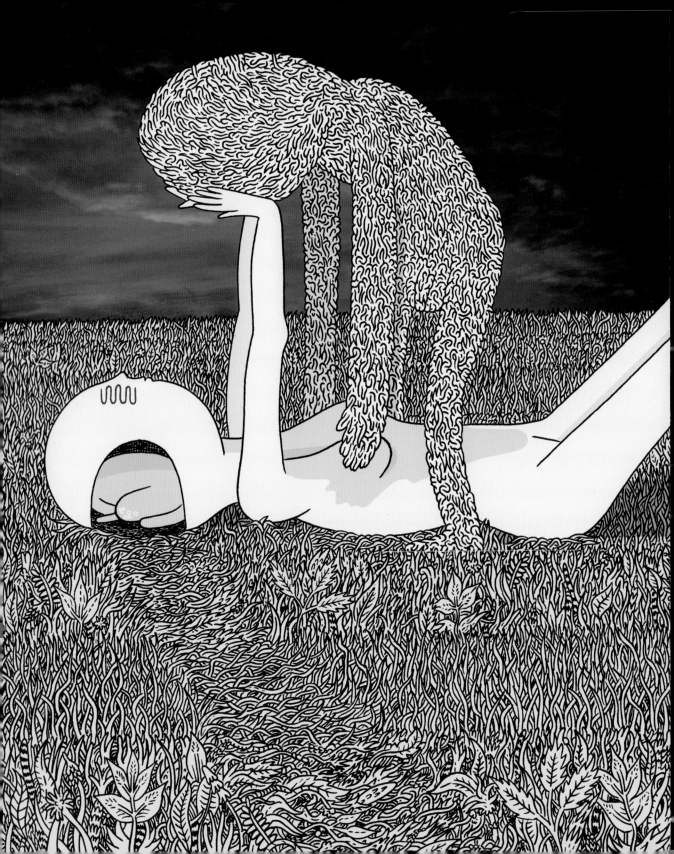

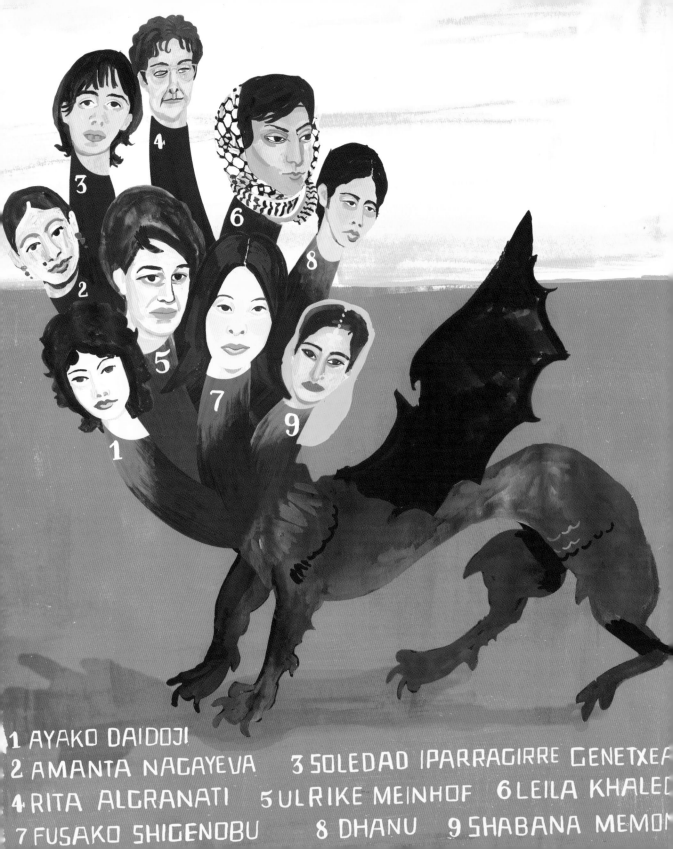

1 AYAKO DAIDOJI
2 AMANTA NAGAYEVA 3 SOLEDAD IPARRAGIRRE GENETXEA
4 RITA ALGRANATI 5 ULRIKE MEINHOF 6 LEILA KHALED
7 FUSAKO SHIGENOBU 8 DHANU 9 SHABANA MEMON

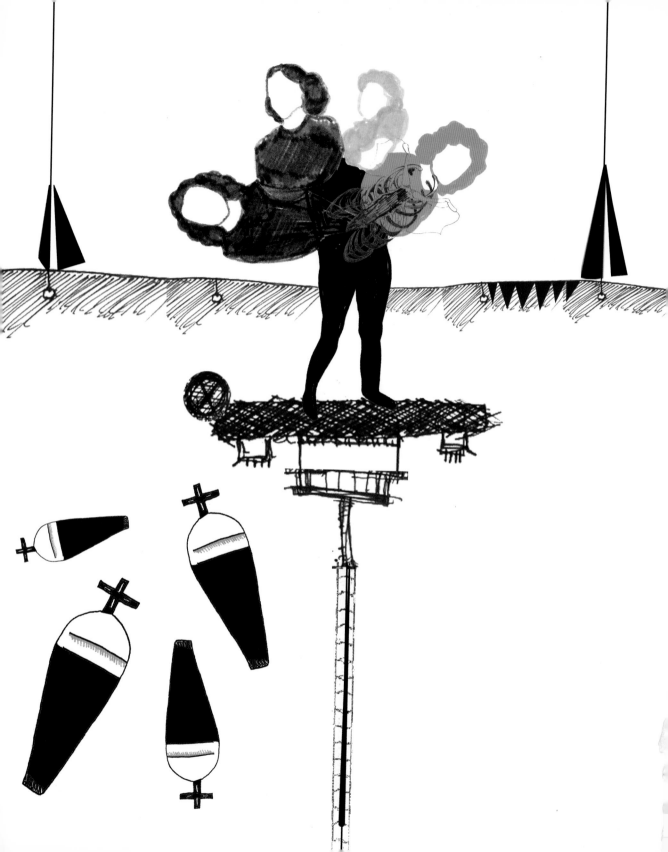

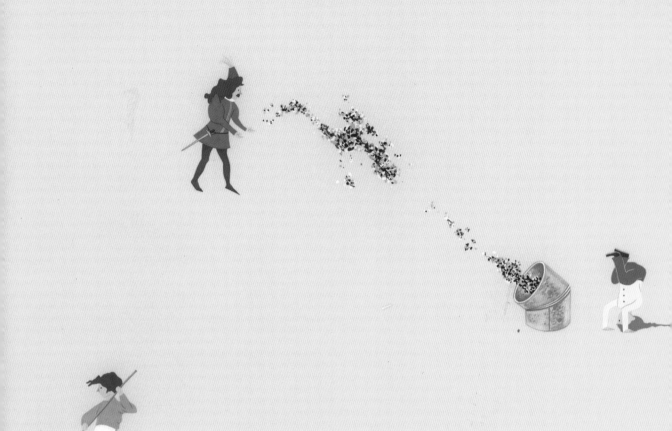

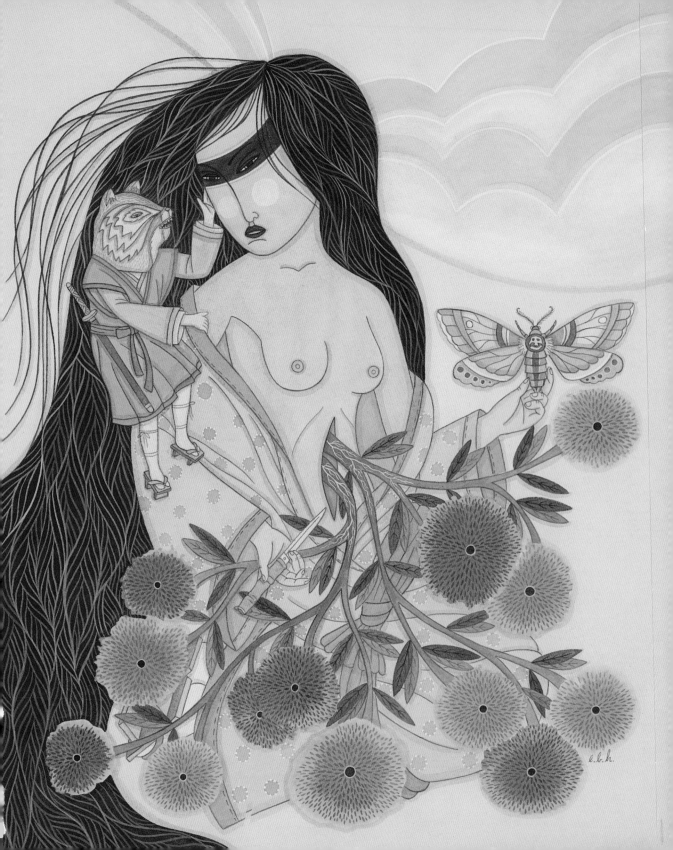

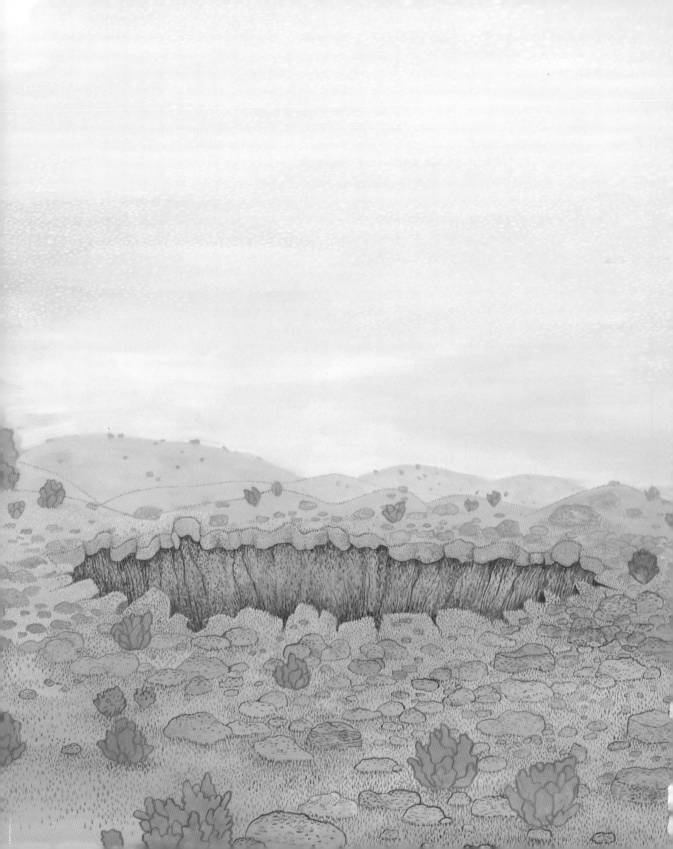

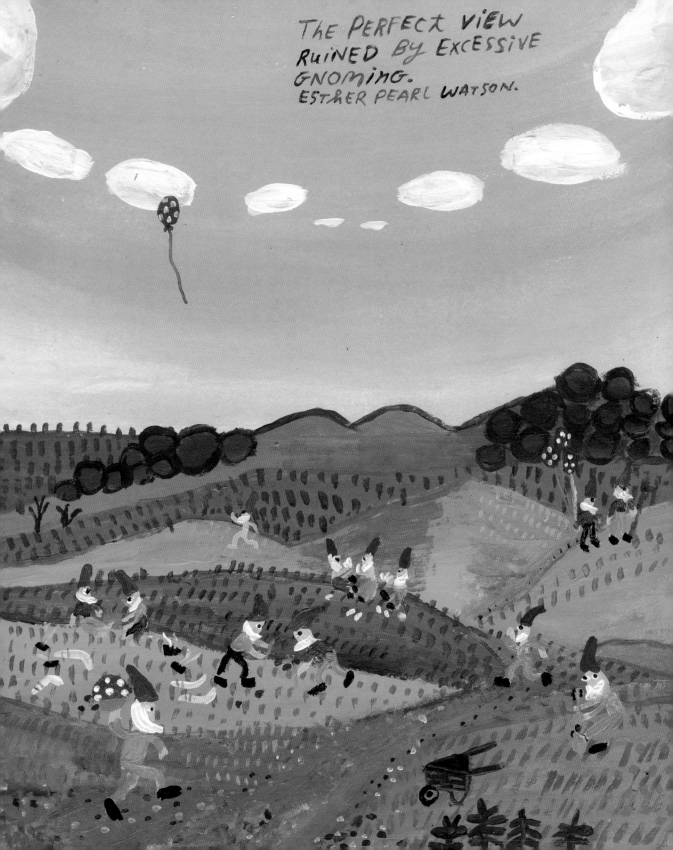

IN THE GROUND

HENRIK
DRESCHER

KATE
O'CONNOR

KATE
INGAMAN-
BURT

ISAAC
TOBIN

IRINA
TROITSKAYA

BEN
FINER

CHRISTOPHER
DAVID RYAN

PASCAL
BLANCHET

CALEF
BROWN

MATT
LAMOTHE

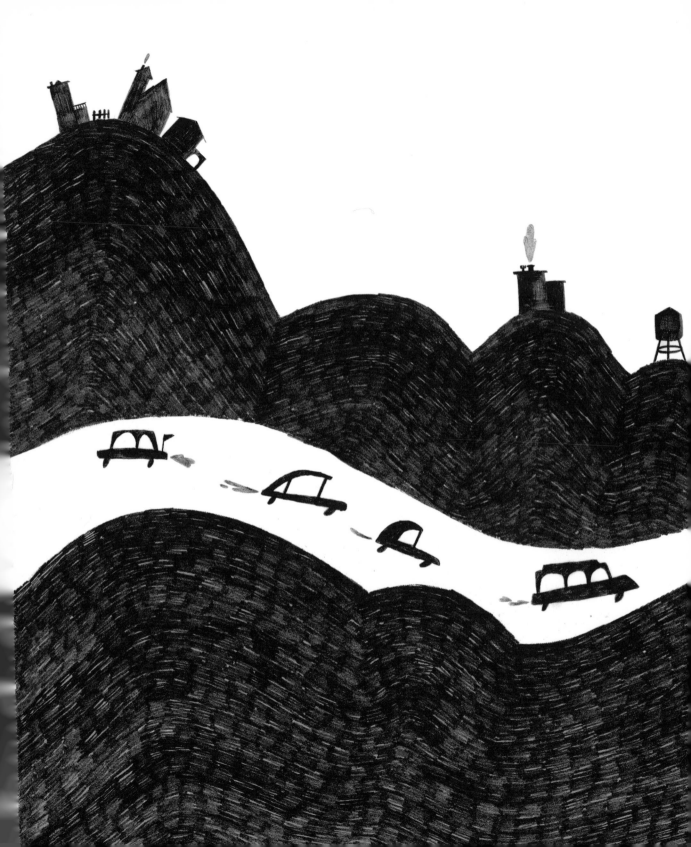

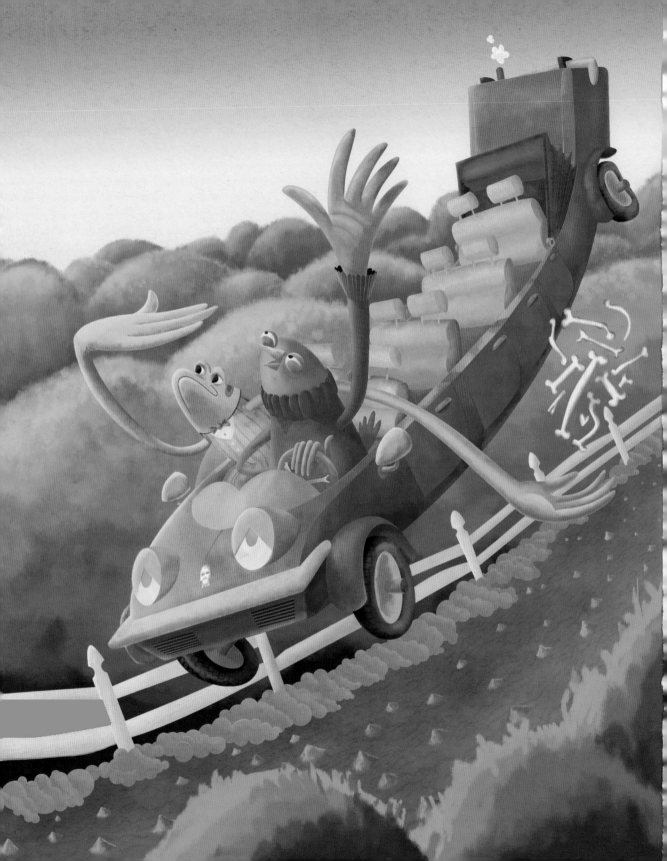

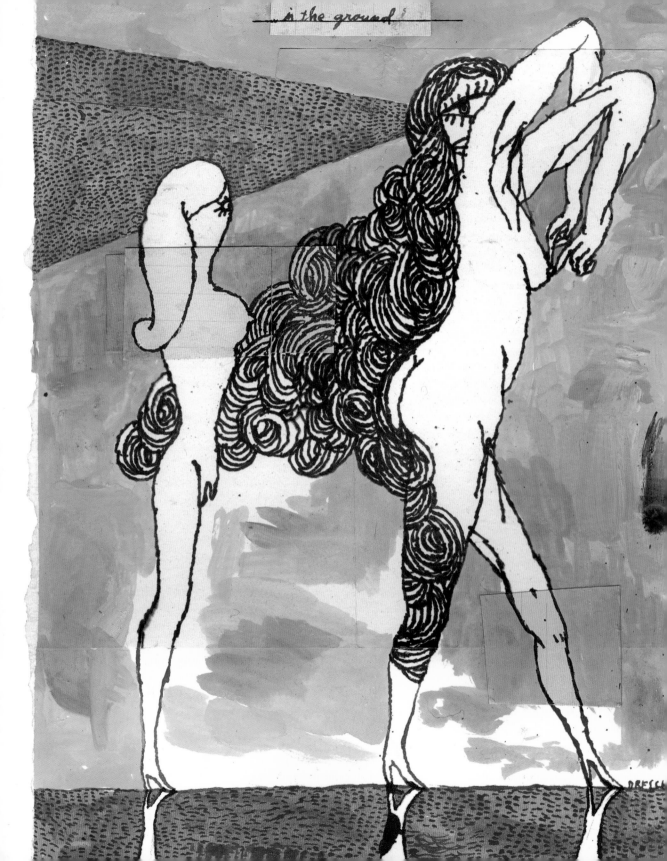

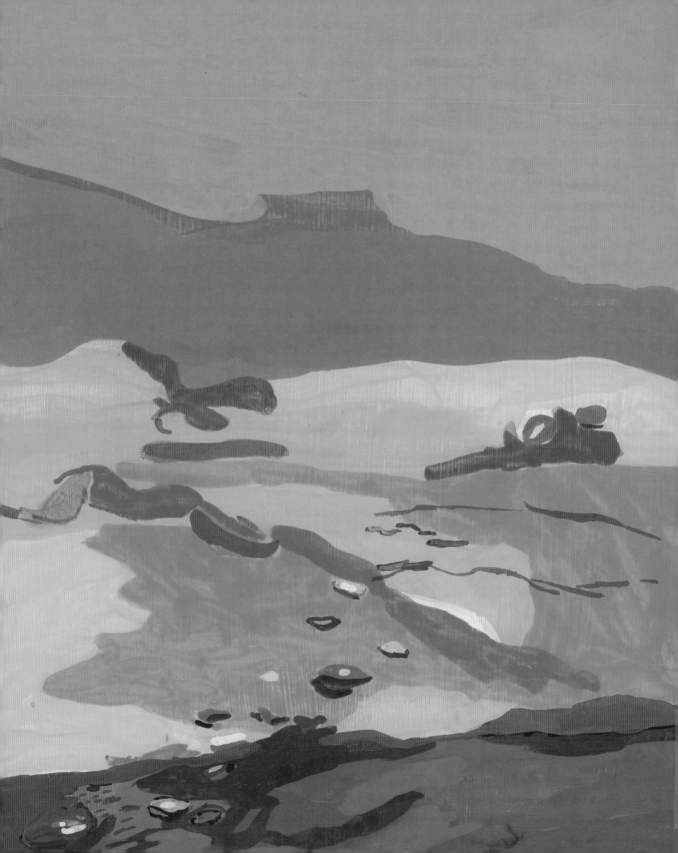

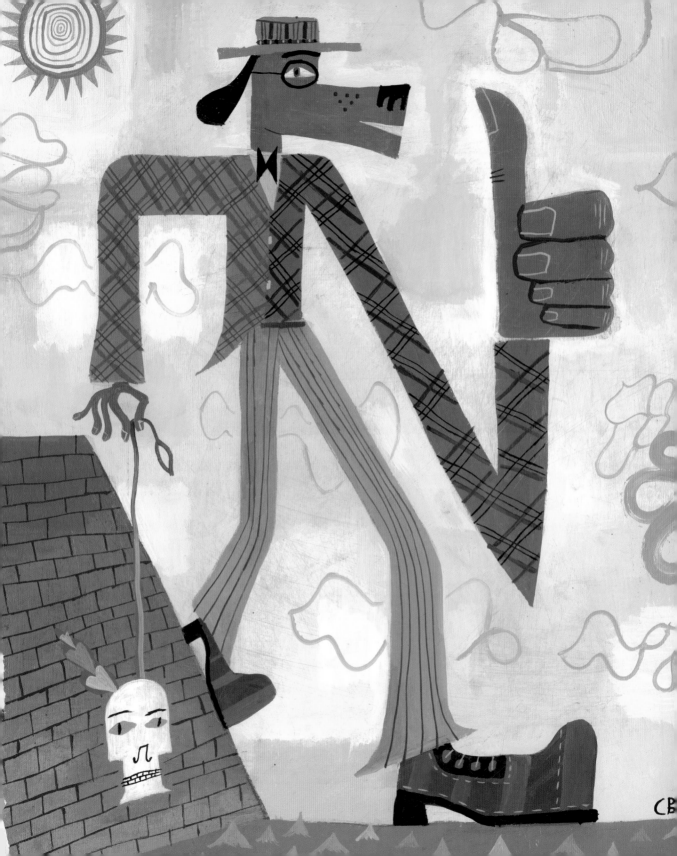

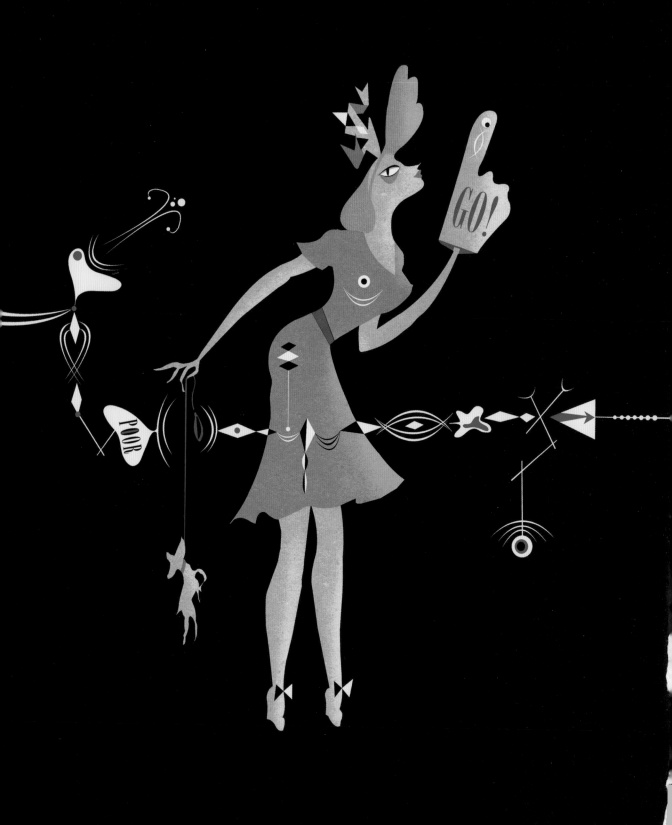

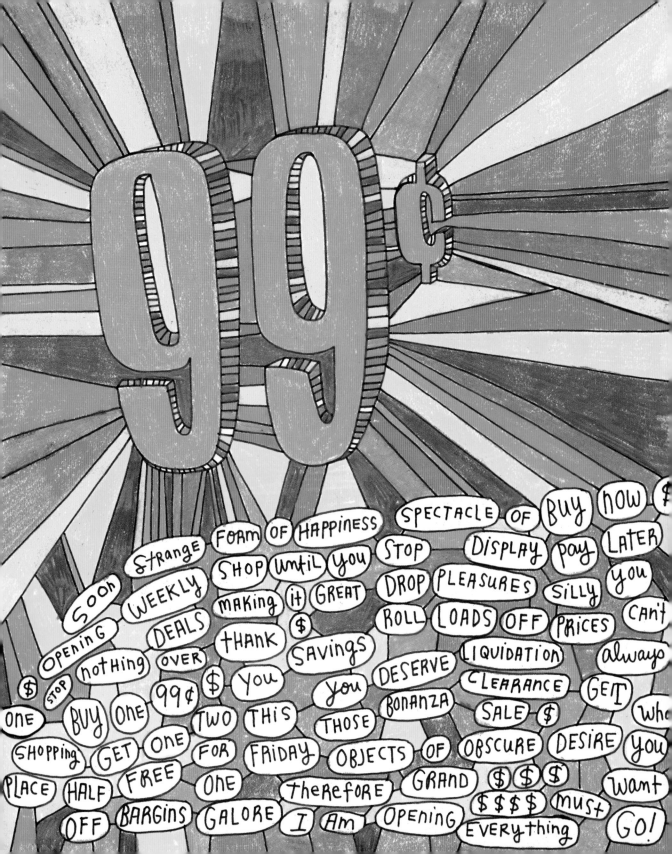

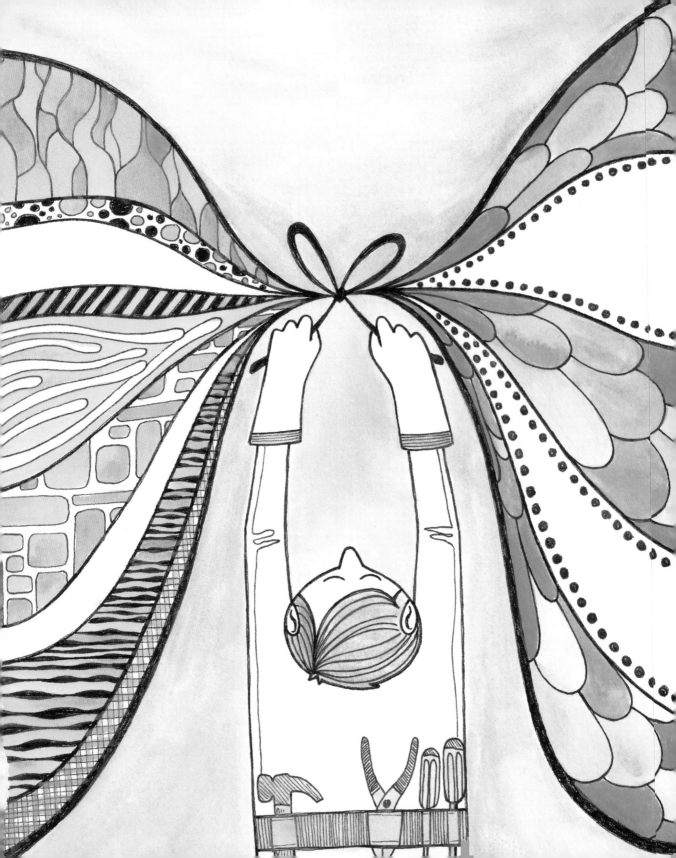

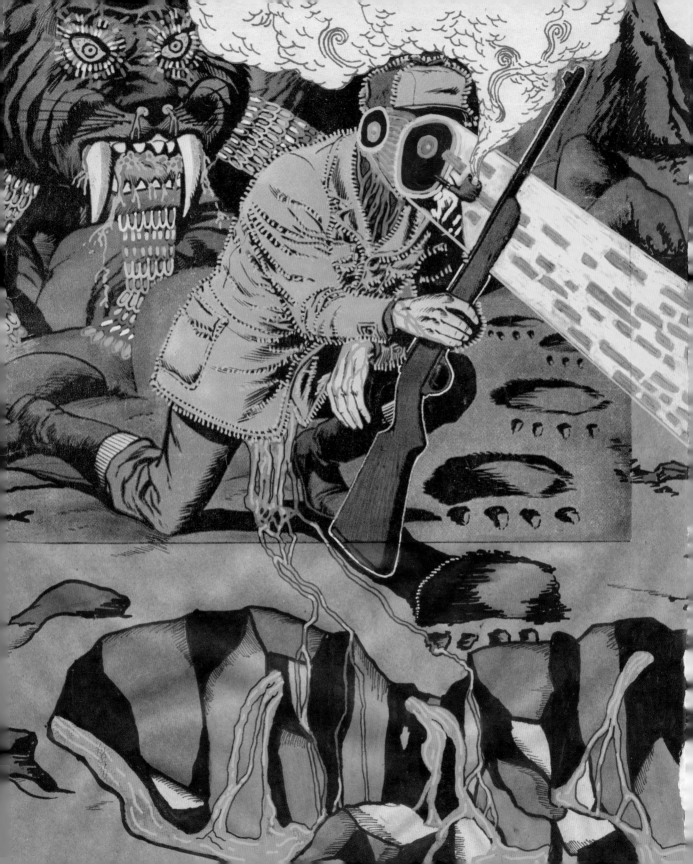

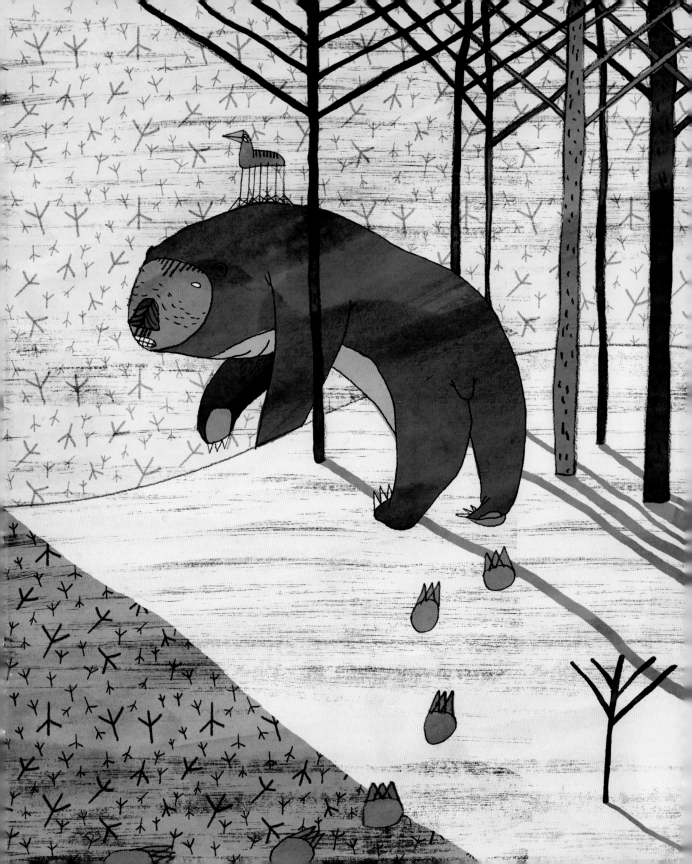

MATTE
EPHENS

SHLEY G
ND DREW

TOM
NEELY

AARON
ESHON

ORDAN
CRANE

LISA
ONGDON

SUSIE
AHREMANI

MIKE
ERTINO

DAVID
EATLEY

JIM
TOTEN

IN THE VILLAGE

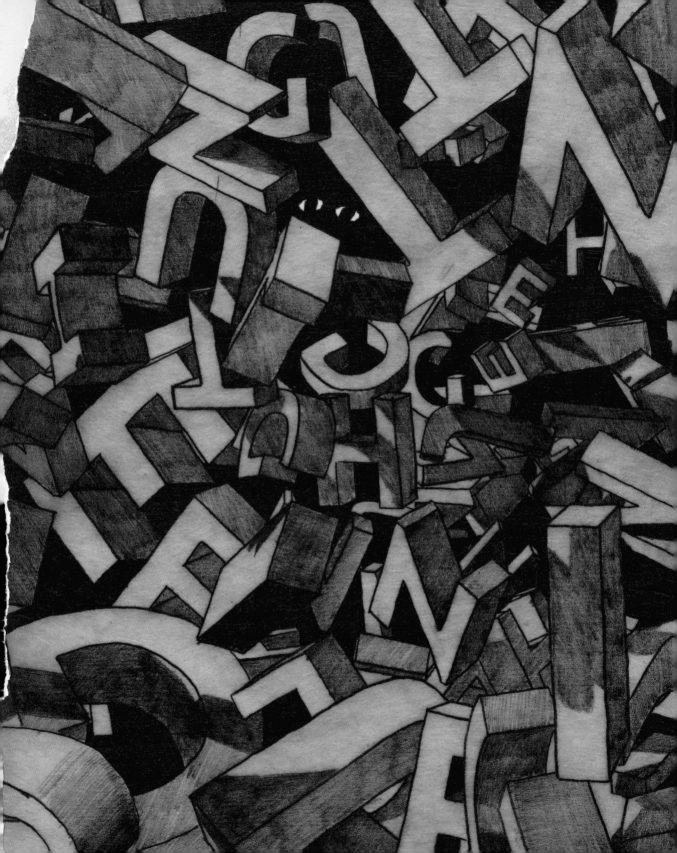

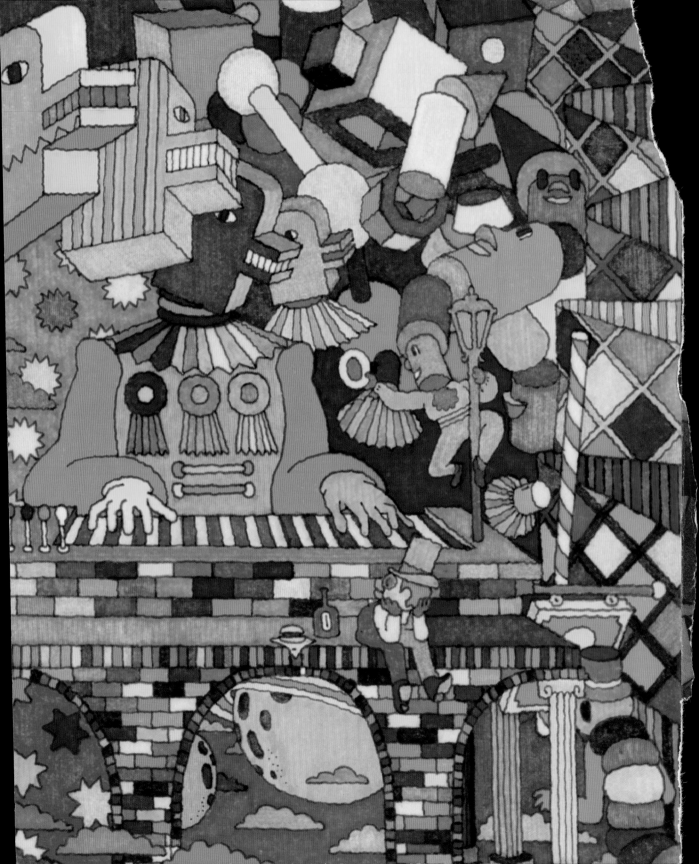

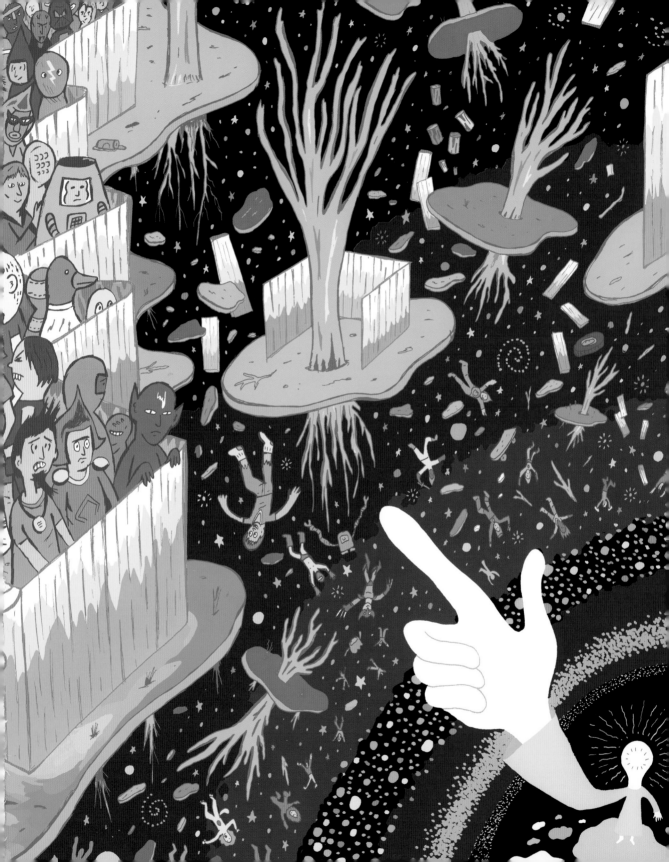

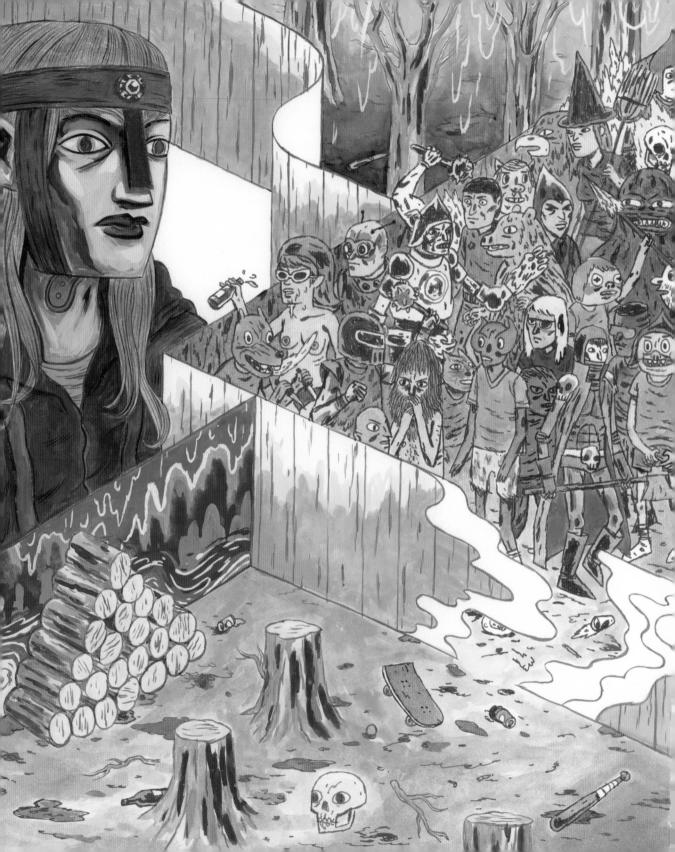

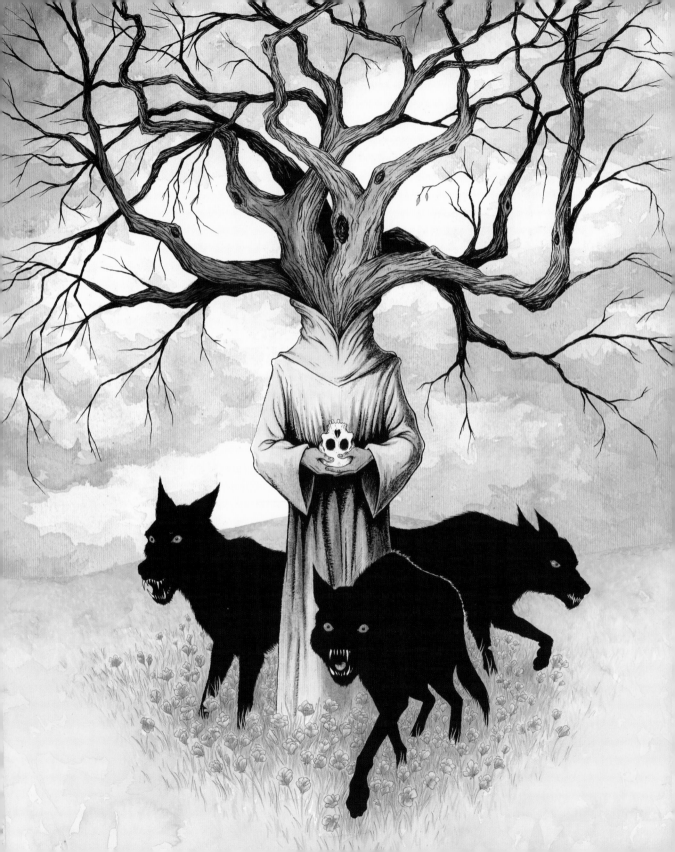

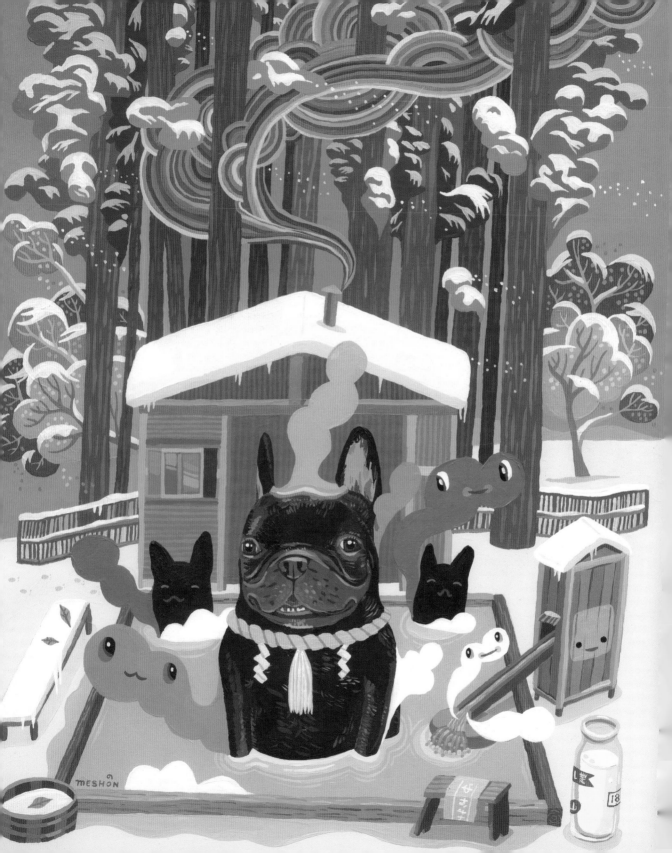

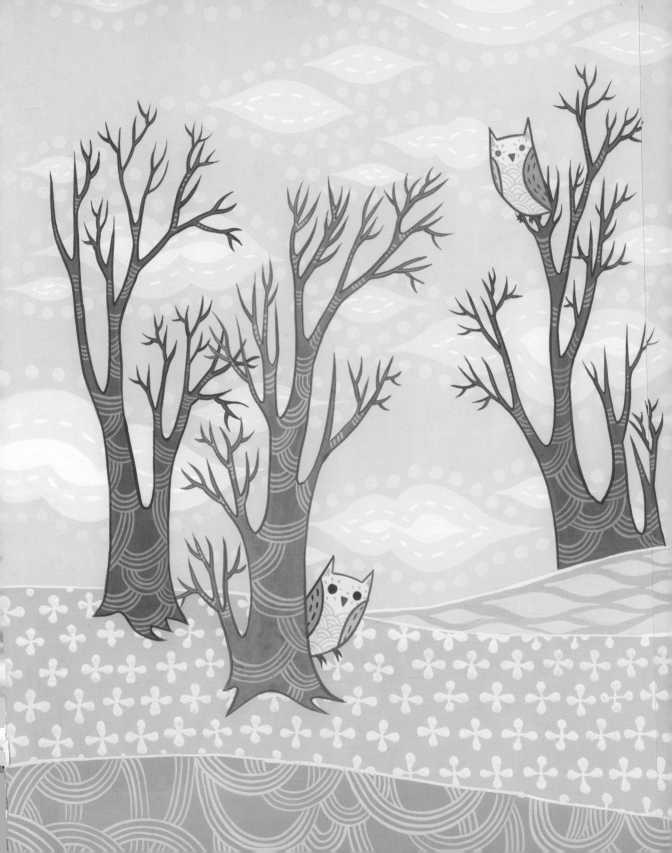

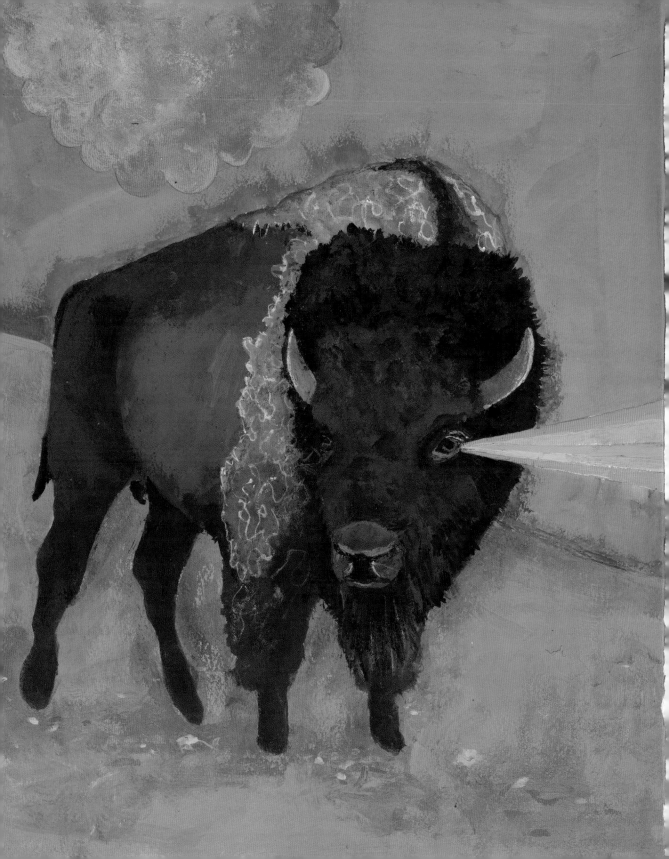

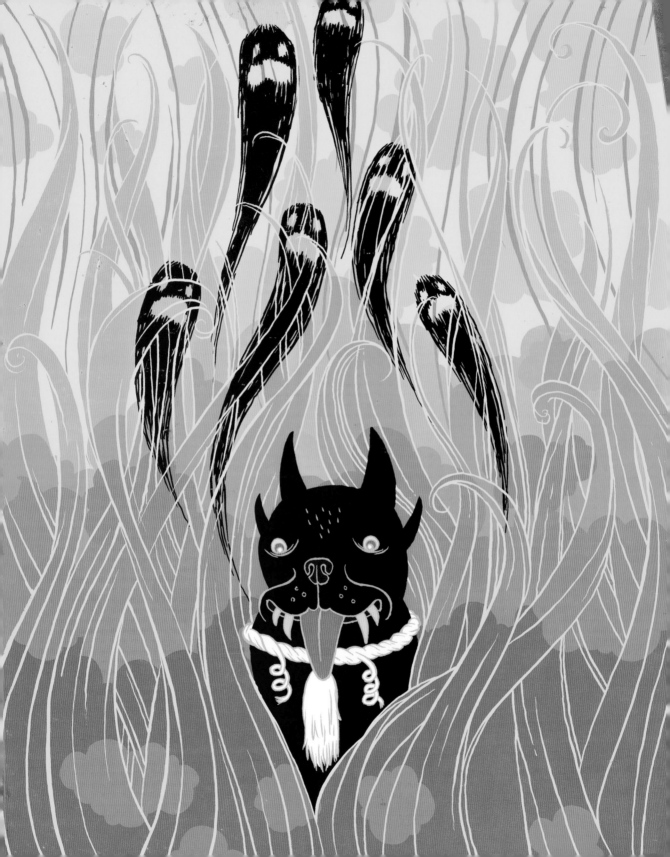

IN THE JUNGLE

MARCUS
OAKLEY

CAITLIN
KEEGAN

TRAVIS
MILLARD

JILL
BLISS

STUART
OLAKOVIC

JORDIN
ISIP

PAUL
ORNSCHE-
MEIER

JOE
MCLAREN

BETSY
WALTON

LIZ
ZANIS

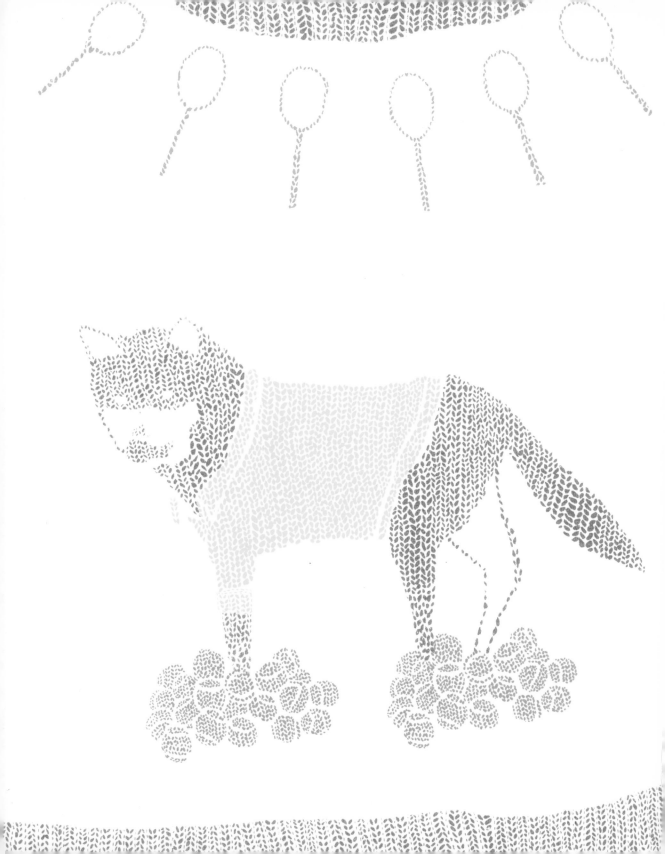

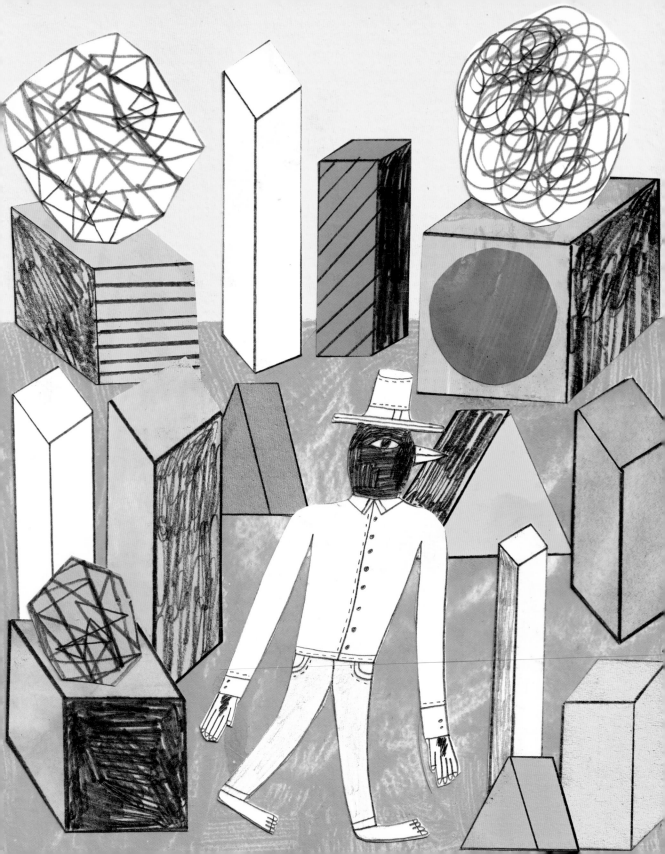

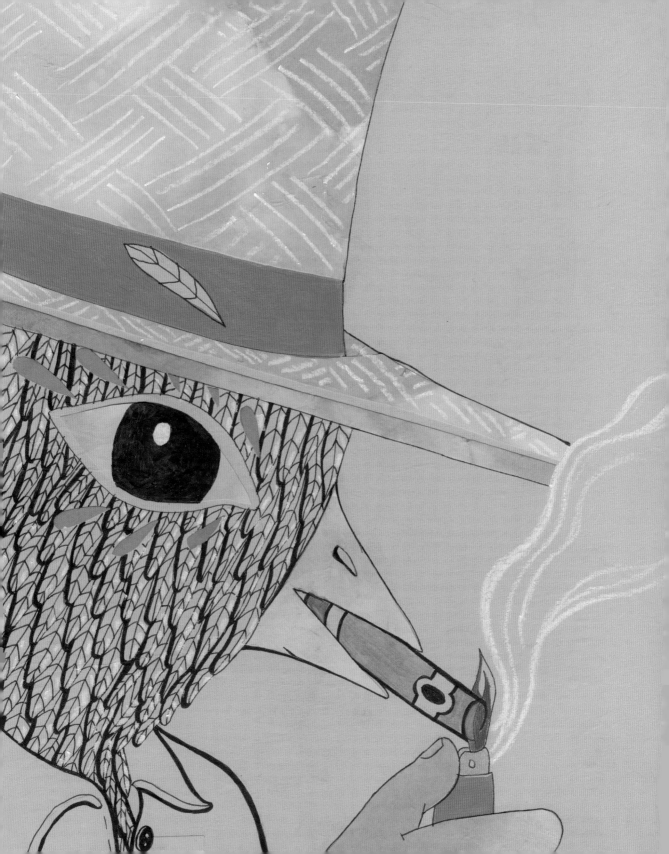

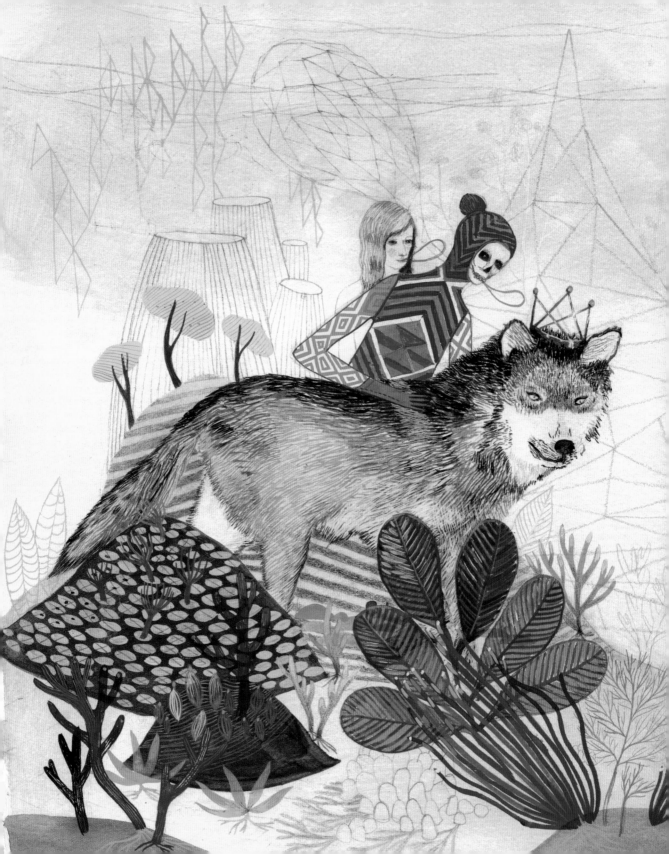

BEN FINER was raised in the rolling Green Mountains of Vermont. His youth was spent collecting rocks, bottles, bugs, snakes, and bits of rusted metal he dug out of his backyard. He read comics. He ate bagels. He clawed at dirt. From 1998 to 2002 Ben attended the Rhode Island School of Design, where he received his Bachelor of Fine Arts Degree in Painting. In May 2009, he earned his master's degree from Parsons the New School for Design. He currently lives in Brooklyn, New York, and continues to claw at dirt when he finds opportunity.
www.benfiner.com

ALYSON FOX makes things from paper, fabric, books, ceramics, thread, wallpaper, office supplies, photographs, old tattered things, new polished things, furniture, and cement. She has degrees in photography, sculpture, and installation art. She enjoys designing things for commercial ends and designing things for no end at all. Alyson has been working on an ongoing series of drawings depicting strange half-stories and invented family histories. Her work has been published in the *New York Times*, *Nylon*, *Domino*, and *Lucky*. Her most recent shows include 20 to Watch at the Austin Museum of Art; Secret Garden at the Tinlark gallery in Hollywood; and Portes Ouvertes des Ateliers de Belleville in Paris. She is currently working on a small line of housewares and on a clothing line with Brooklyn-based designer Caitlin Mociun. She lives and works in Austin, Texas.
www.alysonfox.com

SARAJO FRIEDEN is an artist and illustrator who lives in Los Angeles with her son. She has exhibited her artwork at the LittleBird Gallery, Rare Device, and Tinlark, as well as in other parts of the world, including London, Italy, and Australia. She finds inspiration everywhere: in nature, music, folktales, puppets, Paul Klee, textiles, her Hungarian grandparents, and the films of Jacques Tati, to name a few. She works in a variety of mediums including gouache, painted and cut paper, and embroidery. Her work frequently appears in magazines, books, and other media. She loves to spend time in the ocean, and her friends say she was a merperson in a former life.
www.sarajofrieden.com

SUSIE GHAHREMANI is a graduate of the Rhode Island School of Design. Her artwork combines her love of nature, animals, music, and patterns, and has appeared in the *New York Times*, *American Illustration*, and art galleries internationally. Most recently, her paintings were featured in a signature stationery line for Chronicle Books and the highly acclaimed nature book series *I Love Dirt*. Born and raised in Chicago, Susie now happily spends her time painting, crafting, and tending to her pet finches and cat in San Diego, California.
www.boygirlparty.com

ASHLEY GOLDBERG, twenty-seven, and **DREW BELL**, thirty, are creative partners in crime, living and loving in Portland, Oregon. Ashley believes great emotion can be conveyed in a simple gesture or look. The characters she creates, whether monsters or little girls, are simple, humorous, empathetic, and a little bit pathetic. "I strongly believe that what you're happiest doing at five is what you will be happiest doing your entire life. Growing up, I endlessly drew and embroidered onto washcloths that my grandma gave me little creatures and animals that I desperately wanted to live in the woods of my backyard. In my mind these creatures had tiny, magnificent, ornate lairs in the trunks of old trees (which I also drew, along with maps of how to get there). And although these creatures were elusive and shy, they always decided to befriend me. Over the years, my creatures have become decidedly more design-driven, but a part of me is still just drawing little friends to have."
www.ashleyganddrew.com

Born among the briars and brambles in the backwoods of Klamath Falls, Oregon, **EVAN BENJAMIN HARRIS** grew up with little knowledge of the bourgeois big city fine arts. So he dove into the recesses of his own imagination and embraced the fables and folklore that fascinated him. With little to do but draw, he did exactly that. Now older, things haven't changed much. The stories he created as a child are still present in his paintings. With diligence and hard work, Evan's crude stick figures became the more clearly defined images you see today. With no formal art training, he creates on his own terms.
www.evanbharris.com

Born in New Hampshire, **JOSEPH HART** lives and works in New York City. His work focuses on belief and value systems: specifically, exchanges between hierarchies, economics, the politics of control, and personal priorities. Hart's mixed media works on paper have been exhibited in galleries and museums, both nationally and internationally.
www.joseph-hart.com

THE HEADS OF STATE is the design and illustration studio Jason Kernevich and Dustin Summers founded in Philadelphia in 2002. Together they have garnered dozens of awards for their posters, illustrations, and book covers, which combine a restrained graphic style with their sharp intellect. Clients include the *New York Times*, Penguin, the School of Visual Arts, and *Wired*, as well as musical acts R.E.M. and Wilco. Kernevich and Summers teach at Tyler School of Art in Philadelphia, where they both studied.
www.theheadsofstate.com

DAVID HEATLEY's book *My Brain Is Hanging Upside Down* was published by Pantheon Books in the United States and Jonathan Cape in the U.K. in 2008. A performance for his 2008 tour, which included music, slides, and break dancing, is documented on Google's author channel on YouTube. A mini-LP soundtrack for the book, produced by Grammy award–winner Peter Wade, was released by WonderSound Records in October '08 and is available on iTunes. He sometimes collaborates on comic strips for the *New York Times* with his wife, the writer Rebecca Gopoian.
www.davidheatley.com

Embracing muses from the streets of experience to the mazes of subconsciousness, from the ruins of history to the traces of the future, the work of San Francisco artist and illustrator **MAXWELL LOREN HOLYOKE-HIRSCH** is a bold articulation of human potential. Ambiguous toward boundaries and keen on variety, his works stand in the wake of an artisan's constant and simultaneous tearing down, building up, and re-invention.
www.lorenholyoke.com

KATY HORAN thinks of her creations as folk art from an imaginary world. Based on a wide variety of interests and influences, her work tells stories about the characters and communities that populate this world. Originally from Texas, Katy has lived in five different cities and isn't ready to stop moving quite yet. Since receiving her BFA in Illustration from the RISD in 2003, she has shown her work in New York, Los Angeles, San Francisco, Portland, and Louisville. When not painting pictures of witches and horned ladies, Katy likes to bake pies, watch movies, and play the banjo.
www.katyart.com

PAUL HORNSCHEMEIER is the author of the series *Forlorn Funnies*, and the graphic novels *Mother, Come Home*; *The Three Paradoxes*; and *Life with Mr. Dangerous*, as well as the short story collections *Let Us Be Perfectly Clear* and *All and Sundry*. His work has been translated and praised internationally and his prose, comics, and drawings have appeared in a variety of publications including *The Best American Nonrequired Reading*, Life magazine, and the *Wall Street Journal*. He lives and works in Chicago.
www.margomitchell.com

MEG HUNT is a twenty-five-year-old jack of all trades, but currently works as an illustrator and art maker outside of Phoenix, Arizona. Growing up by the sea in Connecticut, Meg learned from an early age that drawing was fun and now keeps that sense of play in her work no matter what the project. Her work is influenced by old children's books, retro patterns, sci-fi, architecture, fun packaging, propaganda war posters, horror stories, toys, travel, myths/legends, and strange conversations. Her world is inhabited by colorful animals, strange monsters, secret meetings, people in disguises, inconceivable surroundings — a utopia of the charmingly weird. Her clients have included the *Washington Post*, Oxford University Press, HOW magazine, Fantagraphics Books, Threadless, *Nickelodeon Magazine*, *Las Vegas Weekly*, *Utne Reader*, *Yale Alumni Magazine*, and many more.
www.meghunt.com

JORDIN ISIP is from Queens, New York, and has lived in Brooklyn since graduating from Rhode Island School of Design. His mixed-media images have been published in numerous publications including the *Atlantic Monthly*, *Juxtapoz*, the *New York Times*, *Rolling Stone*, and *Time*. Jordin also exhibits in galleries, curates shows, and teaches at Parsons the New School for Design and the Pratt Institute.
www.jordinisip.com

TAKASHI IWASAKI (b. 1982, Hokkaido, Japan) has been intrigued by the act of making art since he was little. In 2002 he moved to Winnipeg, Canada, which he now calls his new hometown, to study Fine Arts at the University of Manitoba. He has been creating abstract images — with acrylic paints, colored pencils, and embroidery threads as his main mediums — to produce a visual diary, documenting his daily life.
www.takashiiwasaki.info

Born in Taiwan and raised in New Jersey, **JAMES JEAN** lives and works in Los Angeles. He graduated from New York City's School of Visual Arts in 2001.
www.jamesjean.com, www.processrecess.com

ARTHUR JONES is a Brooklyn-based illustrator, designer, and animator.
www.byarthurjones.com

KELLY LYNN JONES works in painting, sculpture, and installation. She currently lives in San Francisco pursuing her MFA, which will be obtained in 2010. She has shown across the United States and in the U.K. Kelly also runs www.littlepaperplanes.com.
www.kellylynnjones.com

MEL KADEL, born in 1973, grew up in the Pennsylvania suburbs, and has been living and working in Los Angeles for the last ten years. Mel started out in L.A. by showing work in small galleries and cafés, and working with bands on their record covers. Her drawings are made using stained or found paper, tiny pens, Q-tips, and glue.
www.melkadel.com

ZACHARY KANIN was born malnourished and with little chance of survival. The town doctor hiked for two days through nearby woods until he came to a clearing, where he buried alive the small, barely breathing infant. Despite these early setbacks, Zachary managed to become a cartoonist and writer for the *New Yorker*. His cartoons and writing have also appeared in *Time*, the *Huffington Post's* 23/6, and the Glasgow *Sunday Post*. His first book, *The Short Book*, was published in 2007. He is also a painter and an occasional sex enthusiast.
zkanin@gmail.com

CAITLIN KEEGAN is from a small town known to many as the Home of the Wiffle Ball. When not designing for *Nickelodeon Magazine*, she illustrates for various other publications and takes walks with her dachshund, Ollie. Caitlin currently resides in Brooklyn, where she has lived since graduating from the Rhode Island School of Design. Her past illustration clients have included the *New York Times*, *Nylon*, and *Playgirl*.
www.caitlinkeegan.com

STUART KOLAKOVIC is from the Midlands, U.K., birthplace of Heavy Metal and industrial pollution, and draws pictures, pushes mongo, and listens to Black Sabbath. In that order. He is represented by Heart Artists' Agency.
www.stuartkolakovic.co.uk

CHRIS KYUNG would first and foremost like to thank the academy for its nomination. In addition, he would like to send an important message to our nation's impressionable youth, reminding them that he who smelt it dealt it. Chad lives and works in Brooklyn. You might become friends.
www.infinitearticle.com

LAB PARTNERS is a design/illustration duo based in San Francisco. Sarah Labieniec and Ryan Meis originally met in art school before making the trek out to the West Coast to set up shop. Inspired by nature, quirky narratives, and their animal companions, they work together as a means to share and explore what they love.
www.lp-sf.com

Founded by longtime collaborators Ryan Dunn and Wyeth Hansen, **LABOUR** is a Brooklyn-based creative office that works in film, video, print, audio, apparel, or whatever media suits their fancy. Hailing from Texas and California respectively, the duo met at the Rhode Island School of Design in 1999 and have been working together since. Labour has been recognized for its broad and eclectic approach, having been named Young Guns by the Art Directors Club, New Visual Artists by *Print* magazine, as well as nominated for an Emmy for Individual Achievement in Art Direction and Design.
www.labour-ny.com

MATT LAMOTHE animates and illustrates for ALSO, a small design company he started with friends from the Rhode Island School of Design. When not computering he finds comfort in pastries, coffee, and basic carpentry. He lives and works in a perpetually half-finished Chicago two-story house.
www.also-online.com

MATT LEINES's richly detailed paintings and drawings have been showcased in exhibitions and collections across the globe. Born somewhere in the swamps of Jersey, he now splits his time between Philadelphia and Parts Unknown. His first monograph, *You Are Forgiven*, was published by Free News Projects in 2008.

THE LITTLE FRIENDS OF PRINTMAKING are a husband-and-wife team of artists and designers whose clients include Nike, Liberty Mutual, TBWA\, Harmonix, and National Public Radio. In 2006, they received a Young Guns award from the Art Directors Club, honoring the world's finest emerging creatives under thirty. Their work has been exhibited internationally, and they have been published in several books, including John Foster's *New Masters of Poster Design* (Rockport, 2008).
www.thelittlefriendsofprintmaking.com

After graduating from art school in Stockholm, Sweden, **LAURA LJUNGKVIST** began her career as a professional illustrator working for design firms, magazines, and advertising agencies. She moved to New York in 1993, where she quickly established herself working with a wide range of clients in fields from fashion to finance. Laura is the author and illustrator of five children's books including the *Follow the Line* series for Viking. Laura is branching out: in 2008 her first products were in stores. She lives in Brooklyn with her young daughter, her husband, and their dog.
www.followtheline.com

MIKE LOWERY was born aboard a small boat called the Rygerfjord that was traveling from Scandinavia to the United States. Since then, he has been making art that has been shown in galleries and publications worldwide and is a professor of Illustration at the Savannah College of Art and Design in Atlanta. He lives in nearby Decatur with his wife, Rachel, and their daughter, Allister. They like it when he draws faces on their bananas.
www.ArgyleAcademy.com

SOPHIA MARTINECK was born in 1981 in a small town in the former East Germany. From 2001 to 2007 she studied Illustration at the University of the Arts in Berlin. During that time she studied Fine Art in New York for four months, and spent nine months in Liverpool studying Illustration. Since graduating she has been working as a freelance illustrator and designer for various newspapers such as the *New York Times*, *NZZ* (Zurich), and the *Guardian* (London), and has also had work published in *American Illustration* and *3×3*. At the moment she is at work on an animation based project as a scholarship holder in Berlin.
www.martineck.com

JOE MCLAREN is a freelance illustrator living and working in rural Kent, U.K. He studied illustration at Brighton University, graduating in 2003. He cites 1960s Eastern European illustration as an inspiration, as well as mid-twentieth century English illustration, especially Edward Bawden and Eric Ravilious. In recent years he has completed book covers for Penguin, Faber, and White's Books, among others, and is a regular illustrato for the (London) *Times* and *Financial Times*.
www.joemclaren.com

A graduate of the Rhode Island School of Design, **AARON MESHON** now lives and works in New York City. His work has been seen throughout the world in hundreds of publications as well as on products such as lunch boxes, T-shirts, puzzles, stationery, and magnets. Aaron's work has been recognized in a number of illustration annuals and juried awards including: *Graphis*; Society of Illustrators; *RSVP*; *3×3*; AltPick; and *American Illustration* Nos. 23, 24, 25, and 26. Someday, Aaron would like to sell his products from a mobile sweet potato truck in urban Japan.
www.aaronmeshon.com

TRAVIS MILLARD (b. 1975) grew up in the backyard creeks of Olathe, Kansas. In 1997, he founded the Fudge Factory Comics operation, which is now headquartered in Los Angeles. His work has been exhibited in the United States and internationally, and has been published in numerous books and magazines. Some of his more highfalutin titles include *Hey Fudge, Hitten Switches*, and *Farts: A Spotters Guide*.
www.fudgefactorycomics.com

JULIE MORSTAD divides her time between drawing, illustration, animation, and her ultra-busy children, who must be fed and watered at least four times a day. She subsequently almost always drinks cold tea and is usually late. Julie lives in Vancouver, Canada, and is currently working on some new books.
www.juliemorstad.com

EUNICE MOYLE is Creative Director of Hello!Lucky, a custom letterpress and design studio in San Francisco that she co-founded with her sister, Sabrina, in 2003. She spends much of her time musing on the antics of monkeys and other creatures for their line of charming and witty greeting cards, designing fabulous custom wedding invitations, and writing books. She is endlessly inspired by vintage aesthetics of all kinds and has what could probably be considered a serious and possibly problematic addiction to crafting, designing, and making things from scratch.
www.hellolucky.com

LAUREN NASSEF grew up in central Pennsylvania and graduated from the Rhode Island School of Design in 2001. Since then she's been a bakery counter girl, a teacher, a traveler, and a museum program coordinator. Now she is a Chicago-based artist and illustrator living with her husband and dog almost exactly between President Obama's house and Lake Michigan.
www.laurennassef.com

TOM NEELY is a cartoonist and painter living in Los Angeles with his wife and dog. He is the author of *The Blot*, which won a 2007 Ignatz award, and a comic book, *Your Disease Spread Quick*, for the band The Melvins. He is currently working on a new graphic novel, *The Wolf*.
www.iwilldestroyyou.com

ANDERS NILSEN is the author and artist of several graphic novels and comics including *Big Questions, The End, Monologues for the Coming Plague*, and two Ignatz Award winners, *Don't Go Where I Can't Follow* and *Dogs and Water*. His work has been featured in *Kramer's Ergot, Mome, Best American Nonrequired Reading, Best American Comics*, and the *Yale Anthology of Graphic Fiction*, as well as in a variety of magazines and on a number of book covers. His artwork has been exhibited internationally and translated into several languages. Nilsen grew up in both rural northern New Hampshire and Minneapolis, Minnesota. He studied painting and installation at the University of New Mexico in Albuquerque, earning a BFA in 1996, and did a year of graduate work at the School of the Art Institute of Chicago before dropping out to do comics on his own. He currently lives with his wife and their cat in Chicago.
www.andersbrekhusnilsen.com

CHRISTIAN NORTHEAST has been producing artwork and graphics for magazines, newspapers, and advertising since the mid-'90s. His clients include the *New York Times, Time* magazine, the *New Yorker, Rolling Stone, BusinessWeek, GQ, McSweeney's*, the BBC, and Noggin TV. His work has been recognized by *American Illustration, Communication Arts*, and *Print* magazines; the Society of Publication Designers; the National Magazine Awards; and many others. Christian's book *Prayer Requested* is available in stores, and on Amazon.com. He lives in Canada with his wife and two children.
www.christiannortheast.com

MARCUS OAKLEY is a London-based artist/illustrator. Originally from Norfolk, a coastal county in southeast England, Marcus Oakley's work is inspired by many things, both retro and contemporary. These influences include the wonderful harmonic and melodic music of the Beach Boys, the pastoral and folkloric delights of the countryside and the animals that inhabit it, the joys of cycling, the stimulations of tea, the dizzy geometries of architecture and design—and overall the wonders of making stuff.
www.marcusoakley.com

KATE O'CONNOR is a Canadian interdisciplinary artist and art director. Kate grew up in Toronto, Ontario, but has spent time in Halifax, Nova Scotia, where she gained a BFA and a BDES from the Nova Scotia College of Art and Design. She is currently working towards an MFA degree at Yale University in 2010. She has exhibited in Toronto, Halifax, and New York.
katherine.oconnor@yale.edu

LEIF PARSONS was educated in Canada and New York and has degrees in Philosophy and Design. He has been working as an illustrator for a number of years and has been published by a variety of editorial and commercial clients including *Harper's*, the *New York Times, McSweeney's*, and Nike. He has simultaneously been executing personal art work, which has been shown on both coasts, and he just had his first solo show in New York City. Parsons currently lives in Brooklyn and has recently been focused on trying to find the line between looseness and tightness, between deliberate idea and spontaneous expression, between observation and imagination. He is also curious how many times he can draw himself naked and get it published in the *New York Times* (three so far).
www.leifparsons.com

NIGEL PEAKE works from an attic on a quiet road. Past the clutter of out-turned pockets and mounds of paper is a small window looking down onto a row of trees. His drawings usually focus on small-time adventures, cities, the great outdoors, and vernacular buildings. In the past he has shown his art in some corners of the world and has worked as an illustrator with a variety of clients including the Royal Horticultural Society, the Habitat furniture chain, and Ninja Tunes.
www.secondstreet.co.uk

CLAUDIA PEARSON was born and raised in London and spent most family holidays driving through Europe; she was fortunate to grow up in a family of travelers and was always fascinated by other cultures and traditions. For as long as she can remember she sketched everywhere she went. Whether it was men chatting under trees in Colombia, women selling flowers in Martinique, or families traveling by ferry in Samoa, she had to get it down on paper somehow. In 1994 she moved to New York and joined a reputable agency which placed her at the forefront of the commercial illustration world and thus began working with many respected publications including the *New Yorker*, the *New York Times*, and *Elle* magazine, to name but a few. In 2008 her first children's book, *Tribal Alphabet*, was published. It came about from a desire to show kids the amazing breadth of cultures around the world and, sadly, some that will not survive through the next decade. The book has won a Silver Moonbeam Award and the Stuart Brent Award for its contribution in promoting multicultural awareness in children's literature. She continues to work commercially and is developing a range of products consisting of a series of children's books, illustrations for prints, and other paper products.
www.claudiapearson.com

SIMON PEPLOW stumbled out of the Birmingham Institute of Art and Design in 2004, with a First Class BA Honours in Illustration. Interested primarily in the fantastical and the surreal, and the veritable portals of the human condition, he inhabits a delicately constructed vortex, spending the majority of his days downloading information from a tiny cabin situated inside the corpus callosum region of his noggin. Characters are a fundamental part of his work, described by some as whimsical, cute, and sinister in equal measures. He just wishes they were his friends. Simon has worked with a bundle of diverse clients within the creative realm from editorial to animation, advertising, and the Web. He continues to be inspired by his personal imaginings, and is in a state of constant befuddlement as to how the real world operates.
www.simonpeplow.com

MIKE PERRY works in Brooklyn, New York, making books, magazines, newspapers, clothing, drawings, paintings, illustrations, and teaching whenever possible. His first book, *Hand Job*, was published by Princeton Architectural Press, in 2006. "Mike Perry's compendium of hand-drawn type points to the continued relevance of the human touch in modern communication." — *American Craft*, October/November 2007. His second book, titled *Over & Over*, is about pattern design. He is currently working on two new books. In 2007 he started *Untitled*, a magazine that explores his current interests. He has worked with clients such as the *New York Times Magazine, Dwell*, Microsoft Zune, Urban Outfitters, eMusic, and Zoo York. In 2004 he was chosen as one of *Step* magazine's "30 under 30," in 2007 he was chosen as a groundbreaking illustrator by *Computer Arts Projects* magazine, and in 2008 he received *Print* magazine's New Visual Artist award and was one of the ADC Young Guns 6. Doodling away night and day, Perry creates new typefaces and sundry graphics that inevitably evolve into his new work, exercising the great belief that the generating of piles is the sincerest form of creative process. His work has been seen around the world, including in a recent show in London titled *The Place Between Time and Space*.
www.mikeperrystudio.com

Based in Milan, Italy, **EMILIANO PONZI**'s lush brushstrokes create contemporary scenes with unique personalities. His painterly style pops with color and vitality and his work has appeared in magazines, advertising, publishing, children's books, posters, and newspapers. His clients include the *New York Times, Los Angeles Times, Time UK, San Francisco Chronicle, Washington Post, Newsweek, BusinessWeek, Boston Globe, Le Monde, Atlantic Monthly,* Saatchi & Saatchi New York, American Express, Penguin books, *Columbia University Magazine,* United Airlines, Continental Airlines, *Sports Illustrated,* Sperling & Kupfer, and *Indianapolis,* and *More* magazines. Although he is just thirty, Emiliano has won numerous awards and is already recognized as a major talent in Italy's editorial marketplace.
www.emilianoponzi.com

JULIA POTT is an illustrator and animator based in London. She has directed films for Casiotone for the Painfully Alone, Picasso Pictures, and Etsy, and her animation credits include a music promo for the band Of Montreal. Her films have been screened at the YouTube Short Film of the Year Awards, South by Southwest, Pangea Day, and MTV2, among others. Her illustration work has been exhibited in London, Colorado, Ohio, Montreal, and Antwerp, and she recently had a solo show in Guadalajara.
www.juliapott.com

AJ PURDY is a visual communicator, illustrator, zine maker, type enthusiast, exhibiting artist, and creative explorer. Currently he is freelancing and taking on projects in Delaware. In March 2006 he was awarded a year's scholarship in visual communication at the Fabrica Research Center in Italy. He graduated from the University of the Arts in Philadelphia, earning his BFA in Graphic Design in 2003.
www.graphdrome.com

LUKE RAMSEY and his partner, Angela, operate Islands Fold, an artist residency located on Pender Island, B.C., Canada. Luke has collaborated with over seventy different artists to date and has exhibited in Copenhagen, London, New York, Philadelphia, Los Angeles, Portland, Vancouver and Taipei.
www.islandsfold.com

Los Angeles–based artist and illustrator **BRIAN REA** is the former art director for the Op-Ed page of the *New York Times*. He has produced artwork for books, murals, posters, music videos, and magazines around the world. His illustrations have appeared in *Playboy*, the *New York Times, Outside, Men's Journal*, and *The Nation*, and his design clients include Herman Miller, Kate Spade, Honda, Billabong, and MTV. He has exhibited work in Toronto, San Francisco, New York, and Tokyo. A graduate of the Maryland Institute College of Art, Brian's work has been featured in the Art Director's Club, *Print* magazine, *Communication Arts* Illustration and Design Annuals, AIGA's "50 Books, 50 Covers," the One Show, and the *American Illustration* Annual. Brian currently teaches at the Art Center in Pasadena, California, and spends his downtime traveling and surfing.
www.brian-rea.org

CATELL RONCA was born in Switzerland and lives in London. She works for a variety of international clients, mainly in book publishing, and has most notably created a set of six stamps for the British Royal Mail. Her work is a mix of gouache paintings and digital manipulation. She also teaches illustration at various universities across the United Kingdom. She loves traveling, observing people, and cooking.
www.catellronca.co.uk

Brooklyn-based painter/illustrator/animator **JONATHON ROSEN** was trained in printmaking and electronic music. His is the hand behind the Ichabod Crane (Johnny Depp) drawings in Tim Burton's *Sleepy Hollow*. Widely published, his work ranges from underground comics (*Snake-eyes, Hopital Brut, Ganzfeld, Nozone*), to CD covers (*The Manson Family* opera, Ryuichi Sakamoto, Fast 'n' Bulbous, Marc Ducret), to mainstream periodicals such as the *New York Times* Science Section, *Rolling Stone, Time, Details, Mother Jones, Eye*, and *ID*. He has done live video-instrumental performances with composer Tom Recchion at Redcat for MOCA in Los Angeles, toured the U.K. with composer Tim Berne's Paraphrase, and recently did a series at Columbia University with Christopher O'Riley. His work has been exhibited at P.S.1; La Luz de Jesus; and Kunst-Werk, Berlin; and his books *Intestinal Fortitude* and *The Birth of Machine Consciousness* are in the permanent collection of the Metropolitan Museum in New York. Interested in the interaction of machines and the body, he strives to create work that functions as a continuous Rorschach test upon the unconscious.
www.jrosen.org

JULIA ROTHMAN has made illustrations for many companies, from My Little Pony to *Playgirl* magazine. Her pattern designs can be seen on wallpaper, greeting cards, gift wrap, notebooks, quilts, sheets, plates, mugs, and magnets. She is part of a three-person design company called ALSO, which mostly creates Web sites for independent companies. For fun she writes a blog called Book By Its Cover, which features a nice-looking art book daily. She grew up on a small island in the Bronx called City Island, which few New Yorkers even know about. Currently she resides in a tiny apartment with her husband and terrier in Brooklyn. While she constantly dreams of moving to big, beautiful places far away, realistically, she will probably never leave New York City.
www.juliarothman.com

London-based illustrator **HARRIET RUSSELL** studied at Glasgow School of Art and Central Saint Martins, London, where she finished her MA in 2001. She has worked for a variety of clients in the U.K., United States, and Europe, including Penguin books, HarperCollins, Random House, Simon and Schuster, the Canadian Centre for Architecture, the *Guardian, Independent on Sunday, Time Out,* Christian Aid, Radley, and *Sainsbury's Magazine.* As well as commissioned work, Harriet has written and illustrated several of her own books, including three children's titles for Italian publisher Edizioni Corraini. Her book of creatively addressed mail, *Envelopes: A Puzzling Journey Through the Royal Mail,* was published by Random House in 2005, and was launched with exhibitions in both London and New York. She has a lighthearted and sometimes slightly surreal approach, often combining a quirky humor or a sense of irony into her images. Hand-drawn lettering, words, and wordplay are also an important part of her work. She is represented by Central Illustration Agency in London, and Bernstein and Andriulli in New York.
www.harrietrussell.co.uk

CHRISTOPHER DAVID RYAN is a Texas-born artist, daydreamer, pseudo-scientist, wannabe astronaut, and untrained intellectual who tends to find inspiration in pretty much anything… especially music, the universe, the human condition, and natural phenomena. Living and working in New York City and Portland, Maine, he focuses his creative energy on both analog and digital work. His client commissions have been focused in the fashion industry, working for such companies as Victoria's Secret, Nike, and Obedient Sons. Some of his personal projects include Sleepyheads, a line of pillows and printed pieces; *As Overheard in the Back of My Mind,* a series of self-published books; and My Little Underground, an online shop that highlights new work quarterly.
www.cdryan.com

CARMEN SEGOVIA was born Barcelona, Spain, in 1978. After an initial period of cinema and theatre studies, she got definitely oriented toward painting and illustration. She contributes today to prestigious newspapers and agencies, while regularly illustrating picture books with international publishers. She also collaborates with bands and music projects. Her work as an illustrator and author has been exhibited and awarded internationally and has been featured in *Society of Illustrators* 49, *American Illustration* 27, *Workbook,* and the *Bologna Fiction Annual.*
www.carmensegovia.net

DAVID SHRIGLEY was born in England in 1968, and currently lives and works in Glasgow, Scotland. He has exhibited his drawings, photographs, and sculptures in galleries and museums worldwide, is the author of many books of drawings, and has written and directed numerous animated films.
www.davidshrigley.com

Buenos Aires–born **LORENA SIMINOVICH** is San Francisco–based illustrator. She owns Petit Collage, a company offering modern art and accessories for children. With a background in graphic design, she worked as a creative director in New York City before relocating to the West Coast and dedicating her time exclusively to art and illustration. Lorena has written and illustrated several children's books.
www.petitcollage.com

LENA SJOBERG lives in a small Swedish village, where she works as an illustrator and writer.
www.lenasjoberg.com

RYAN JACOB SMITH lives in Portland, Oregon, where he enjoys collecting old science books and ephemera from thrift stores, skateboarding, and buying records. He was raised in Orange County, where he passed his early days rock collecting, BMX riding, skating, and Cub Scouting. He graduated, with honors, from Art Center College of Design in Pasadena, California, in 2001. "His narrative work explores themes ranging from the earth and its environment to consciousness, the human body, survival, and hurt and healing. Incorporating the traditions of illustration, painting, and collage, his work is a mingling of intention and improvisation. His innovative pieces bear the marks of their own history; fragments, mistakes, and unconscious marks are incorporated into the composition such that each work represents an honest account of its own development. Combining acrylics, spray paint, silk screen, and graphite, Ryan's work is as much informed by the street culture of his youth as his formal fine art training." – Jennifer Armbrust of Portland's Motel Gallery.
www.ryanjacobsmith.com

MATTE STEPHENS a thirty-four-year-old painter who lives in Portland, Oregon. He is inspired by industrial and graphic design of the mid-twentieth century. He also loves the art of fine artists of the same era, such as Ben Shahn and Paul Klee. He has done illustration work for Herman Miller, American Express, Woodmansterne, Editions Alto, the *Boston Globe*, and magazines such as Disney's F*amily Fun, Eye Weekly, Glow, Fit Pregnancy, ViVi*, and *Endless Vacation* to name a few. He has participated in shows all over the place. You can find his original work on a regular basis at Jonathan Adler and Velocity Art and Design and sometimes in his shop. All of his paintings and illustrations are made traditionally with gouache.
www.matteart.net

JIM STOTEN is an illustrator living and working in London. He graduated from Brighton University in 2003 and since then he has been freelancing. He has worked for a diverse and eclectic mix of clients and he loves doing what he does.
www.jimtheillustrator.co.uk

ISAAC TOBIN is a senior designer at the University of Chicago Press. He earned a BFA in Graphic Design in 2002 from the Rhode Island School of Design. His work has been recognized by the American Institute of Graphic Arts (AIGA), the Association of American University Presses (AAUP), the Type Directors Club (TDC), and *Print* magazine, and has been featured in books published by Die Gestalten Verlag and Laurence King. In his free time he likes to read about food, design typefaces, and hang out with his wife and dog.
www.isaactobin.com

IRINA TROITSKAYA was born and raised in Izhevsk, city of dead ends, sad electronic music, and Finno-Ugric cultural roots. On graduating from the university, where she studied art for five years, Irina quit drawing and worked for a couple of years as a TV journalist. But she always preferred pictures to words. In summer of 2003 Irina packed up and took a chance on Moscow. Since then she has lived in the capital of Russia and works as a freelance illustrator at day and an artist at night. Irina is a tutor of the Visual Communications course at the British Higher School of Art and Design in Moscow. As an illustrator Troitskaya draws for the press, advertising, and book publishing. Her works are in private collections in Russia, Spain, China, Argentina, the United States, and England.
www.irtroit.com

JOEL TRUSSELL is a director/illustrator/animator in Knoxville, Tennessee. His diverse skill set has allowed his work to appear with a variety of clients in different mediums such as *Yo Gabba Gabba*, the *New York Press*, Esurance, and Kidrobot. He is best known for directing music videos for the likes of M. Ward, Morcheeba, Jakob Dylan, and Coldcut, which have appeared in dozens of film festivals worldwide. Before his work as a freelance director, Trussell worked as an animation director in Seattle, animating online projects for clients including Disney, Napster, and Devo.
www.joeltrussell.com

Born in the former East Germany, **HENNING WAGENBRETH** studied at the Kunsthochschule in East Berlin. He worked for two years as an illustrator for books and animated films and did some posters for the citizen movement when the Berlin Wall came down in 1989. In the following years of political transformation he designed many theatre posters using mainly illustration and hand-drawn typography. In 1992 he left for Paris, where he got in touch with a wide variety of artists and publishers. In 1994 he went back to Berlin and started to teach illustration and graphic design as a professor at the University of the Arts. He illustrates books for children and grown-ups, posters, newspapers, magazines, comic strips, and German postal stamps. Recently he created his first stage design for an operetta in Lucerne, Switzerland. He likes to design and digitize hand-drawn typefaces and works on automated illustration systems. Henning Wagenbreth's work shows his interest in combining old graphic printing and drawing techniques with modern digital printing or screen publishing technology. His work has been several times awarded by poster festivals in Berlin, Chaumont, Warsaw, and China and by the German Book Foundation. He has taught graphic design and illustration and exhibited his work in many different places all over the world.
www.wagenbreth.de

BETSY WALTON is a painter based in Portland, Oregon. Her style is informed by a range of influences including Byzantine icon paintings, American folk art, and geometric abstraction. When she is not painting, she might be found looking for a snack, visiting the library, or wandering through the tall trees of the Pacific Northwest.
www.morningcraft.com

ESTHER PEARL WATSON's work has always been about telling stories. With their humor and faux-naïve charm, the works are part fantasy, part homage to the past. Watson's works have been exhibited most recently at the Santa Monica Museum of Art, the Oakland Museum of California, the *L.A. Weekly* Biennial at Track 16, the Kansas City Museum, the Lab at Belmar in Colorado, and the *Beach Museum of Art*. Watson has also taught and lectured extensively, and has created popular cartoon works such as *Unlovable* (released in a special two-volume set by Fantagraphics Books).
www.estherwatson.com

Hong Kong–born **WU WING YEE** was educated in Hong Kong, China, and the United States. Her drawings and sculptures are in the collections of various museums and private collections worldwide. She divides her time between Hong Kong, China, and North America, working as a full-time artist.
www.wuwingyee.com

LIZ ZANIS traffics in eavesdroppings and family histories, often appropriating them for small autobiographical objects. Her nights and weekends are spent wrestling silk screens and printing tiny prints which may or may not become limited edition artist's books. Her work has been exhibited at two libraries, one print studio, one workshop, one Flux Factory, one print center, one museum, and one center for book arts. This summer she hopes to renew her tennis pass and to continue to improve her site.
www.lizzzanis.com

WARD ZWART was born in 1985. He lives and works in Antwerp, Belgium. Secretly he dreams of pandas dressed up in moose costumes, and draws a bunch of portraits with cheap pencils. Ward publishes his own zines and booklets, appears regularly in the Russian magazine *Bolshoi Gorod*, and likes to drink orange juice out of way too big glasses while eating cookies.
wardzwart.carbonmade.com